expressive
flower painting

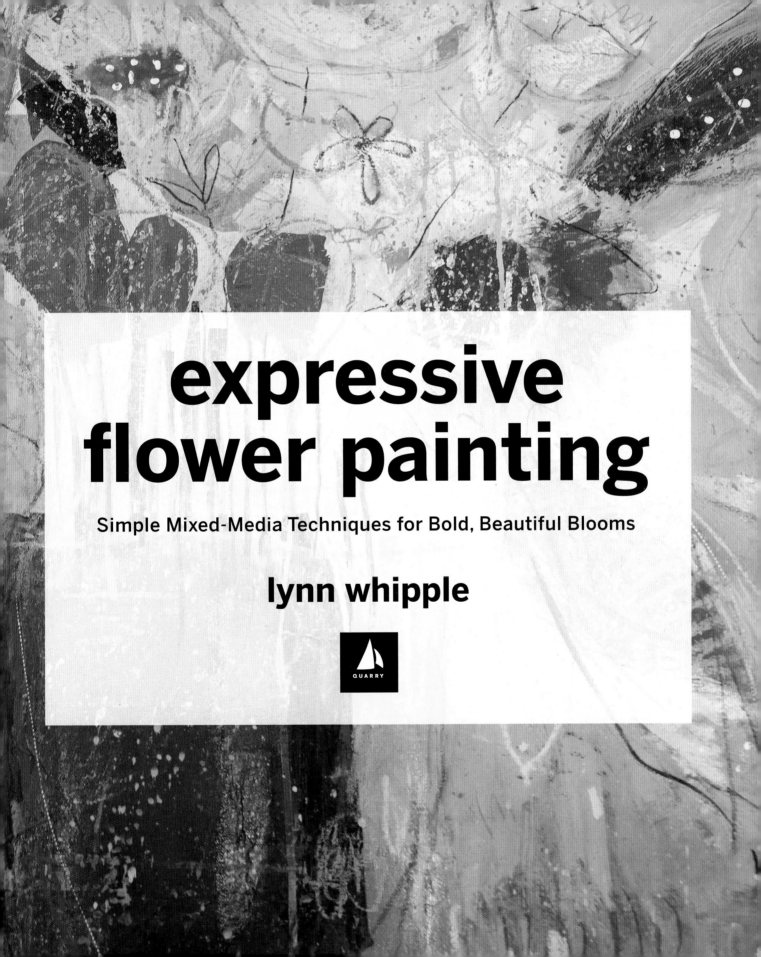

expressive
flower painting

Simple Mixed-Media Techniques for Bold, Beautiful Blooms

lynn whipple

QUARRY

Brimming with creative inspiration, how-to projects, and useful information to enrich your everyday life, Quarto Knows is a favorite destination for those pursuing their interests and passions. Visit our site and dig deeper with our books into your area of interest: Quarto Creates, Quarto Cooks, Quarto Homes, Quarto Lives, Quarto Drives, Quarto Explores, Quarto Gifts, or Quarto Kids.

First Published in 2017 by Quarry Books,
an imprint of The Quarto Group,
100 Cummings Center, Suite 265-D, Beverly, MA 01915, USA.
T (978) 282-9590 F (978) 283-2742 QuartoKnows.com

Quarry Books titles are also available at discount for retail, wholesale, promotional, and bulk purchase. For details, contact the Special Sales Manager by email at specialsales@quarto.com or by mail at The Quarto Group, Attn: Special Sales Manager, 401 Second Avenue North, Suite 310, Minneapolis, MN 55401, USA.

10 9 8 7 6 5 4 3 2 1
ISBN: 978-1-63159-304-8

Digital edition published in 2017
eISBN: 978-1-63159-407-6

Library of Congress Cataloging-in-Publication Data

Whipple, Lynn, author.
Expressive flower painting : simple mixed media techniques for bold, beautiful blooms / Lynn Whipple.
ISBN 9781631593048 (paperback)
Flowers in art. | Mixed media painting—Technique.
LCC ND1400 .W49 2017 | DDC 758/.42—dc23
LCCN 2017010945

Design: Debbie Berne
Cover Image: Lynn Whipple
Page Layout: Debbie Berne
Photography: Terri Zollinger

This book is dedicated to my wonderful Mom and to
my dearest hubby, John. You both live and love fully. You
inspire us all with your sense of humor, artfulness, childlike
curiosity, and enthusiasm. A million thanks for all of the
adventures and especially for the smiles; I love you so!

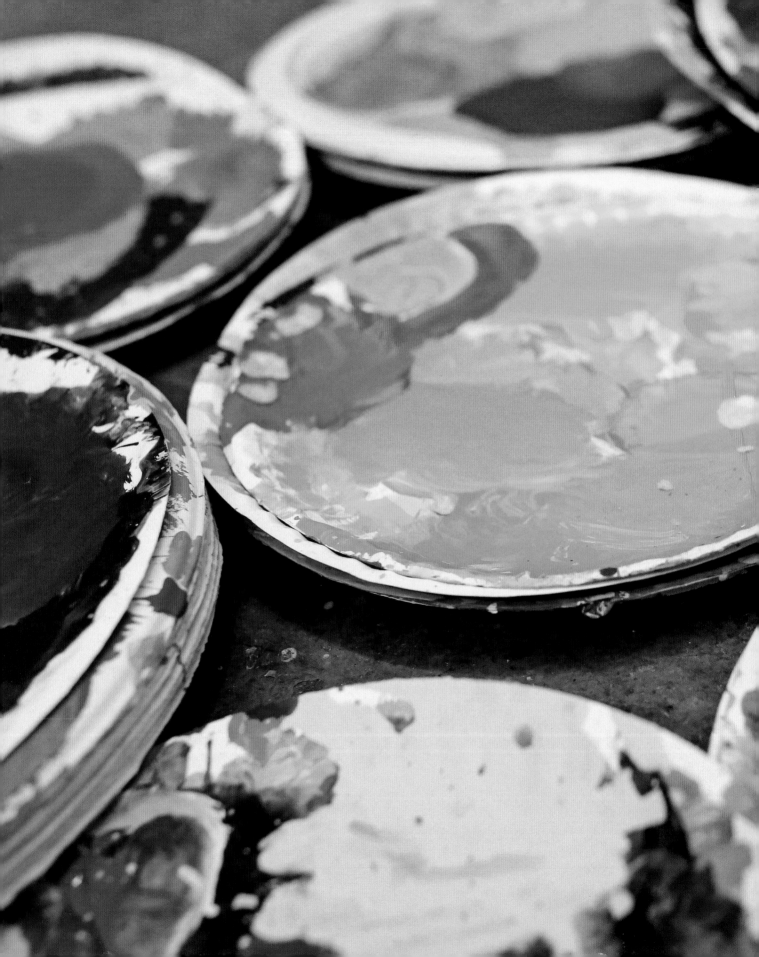

Introduction

Hello! I am so happy you are here!

First, let me say, we are going to have fun! I am incredibly grateful for this opportunity to share with you some ideas and techniques that I know will bring joy to your creative practice. Art making is a glorious romp, where every step and each layer reveals new discoveries and colorful surprises. The most useful and exciting things that I have learned in my studio have come from the simple act of play.

I truly believe that we are all hardwired to create things. To make stuff. To share our work. To find interesting solutions and playfully satisfy our curiosity. Art making is a way to celebrate and explore everything around us. The

most enjoyable art experiences are rooted in discovery. My favorite thing to do in my studio is putter. I turn up the music and simply poke around and try things. No pressure! The game is purely to see what happens . . . to make a mark and respond to that . . . cut out a piece of colored paper, lay it down, move it around, and respond to that. My aim is to make myself laugh as I follow the path in search of a brain surprise. Almost effortlessly, art making ensues!

In this book, we will be working together in simple, joyful ways. We will move our hands and grow confident in our enormously powerful instincts. We will feel the childlike freedom that comes from working in layers. We will celebrate beautiful flowers, a traditional subject matter, with a playful and contemporary approach. We will trust the pull of curiosity to lead us to find fresh, new combinations. We will paint, draw, and explore the fundamentals of line, shape, and mark. We will juggle the balls of color, texture, and design. And throughout this process, we will let the path reveal itself to us in the most inspiring way possible.

With much love and excitement,

XOXO

Lynn

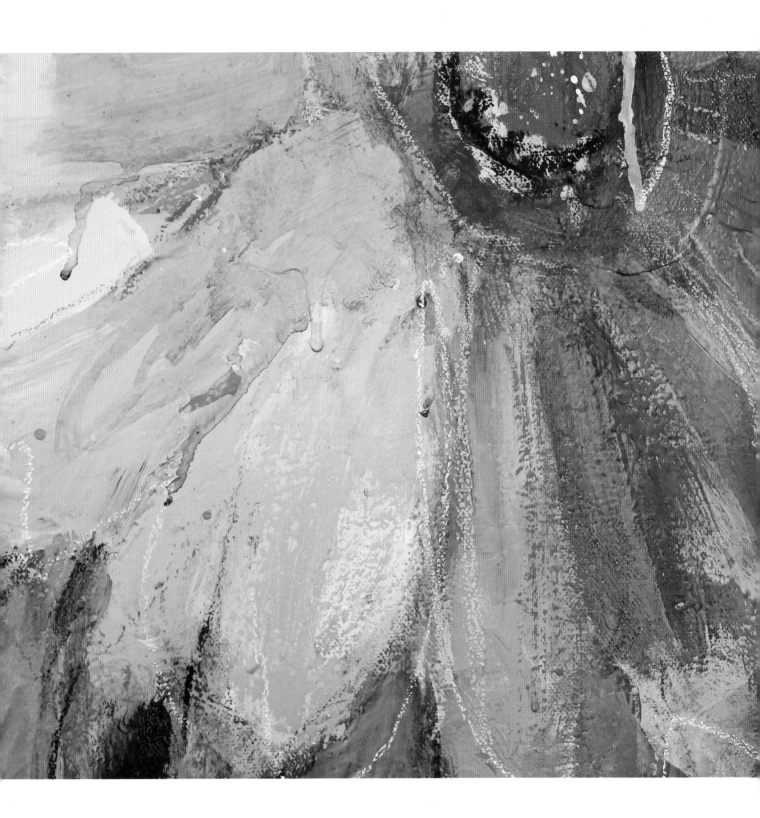

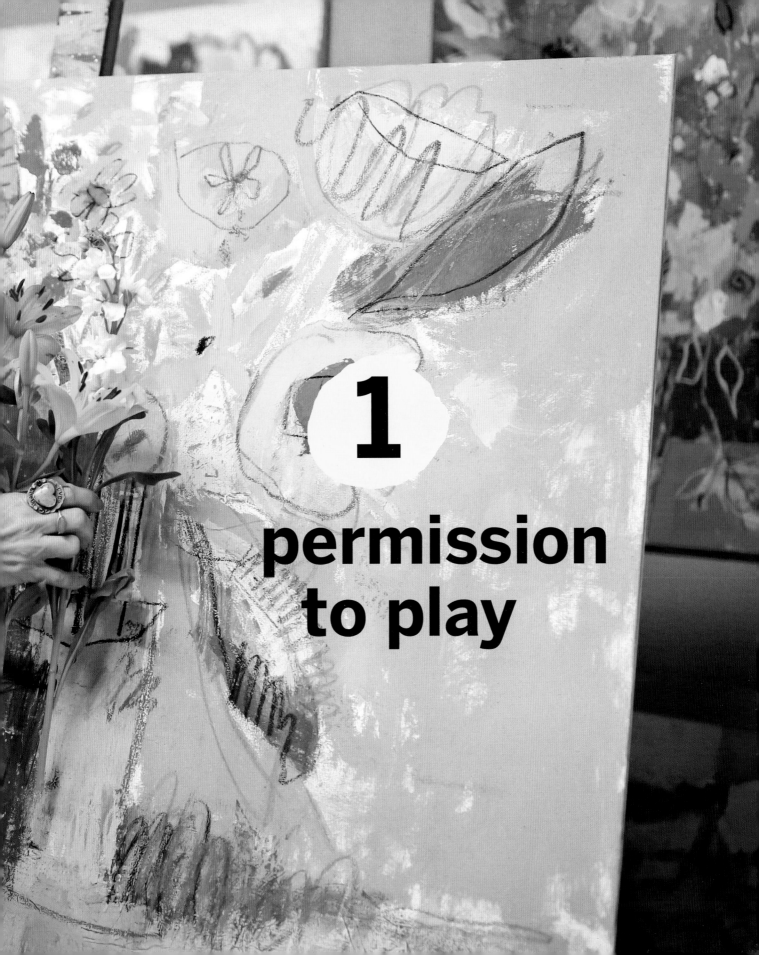

1
permission to play

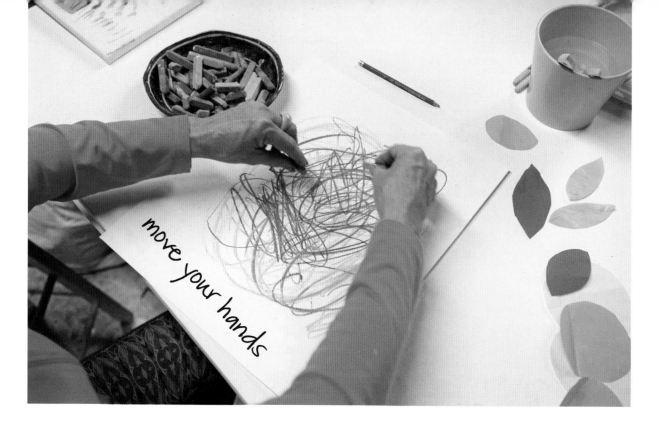

move your hands

"To draw, you must close your eyes and sing." —Pablo Picasso

Does putting the first mark on a blank white canvas ever feel a little scary? You are not alone. We all come across a bit of resistance along the way. I want to offer you one fun idea that will click your creativity into gear. All you need to do is "move your hands." That's it—the key to everything! If you are not sure what to do or how to start, you will find that moving your hands is the answer and the cure. Grab a piece of paper, any writing tool, shut your eyes, and loosely run a line along the page. This childlike motion gets things moving. It is astounding, like priming the pump for your brain. It works. You don't need anything in particular in mind as you scribble. Write your name, doodle, make scratchy marks, circles, or patterns, play with overlapping lines, be free, and let it spill out. Now open your eyes and surprise yourself!

When you begin moving your hands, new things will occur to you. Automatically fill in some of the shapes with color or begin to make patterns as your instincts take over. One of my favorite "move your hands" things to do when I arrive at the studio is to make a thank-you card for someone. When you begin your day in this thoughtful way, you quickly become happily engaged in the moment. There is always someone or

something to appreciate, no matter how small. Your handmade note will send ripples of goodness out into the world.

Another approach is to create a very basic list. Write your list by hand, number it, and illustrate the items with sketches. I love to make each one of my numbers differently: One number is a roman numeral; the number 5 could be written out as the word five; maybe my three is drawn backward just for fun. Embellish your list by adding different colors, a title, and some flourishes.

One more favorite "move your hands" action is to write down your intention for the day. Set your creative course by choosing a few meaningful words. Select a premise or idea that you want to explore. A few examples might include a focus on composition or paying attention to value. Perhaps you use just one encouraging word, such as "PLAY." Place your hand-drawn word or words on your worktable somewhere your eyes will fall upon them during the day. This is a love note to you, and the perfect way to ease into your creativity by moving your hands.

Once you are up and going, things will begin to flow. Before you know it you will be putting down the first layer of color on a giant canvas. You will find yourself sketching "seed drawings" from a fresh pot of blooms that is sitting on your table. Creative things are happening! *Yahoo!*

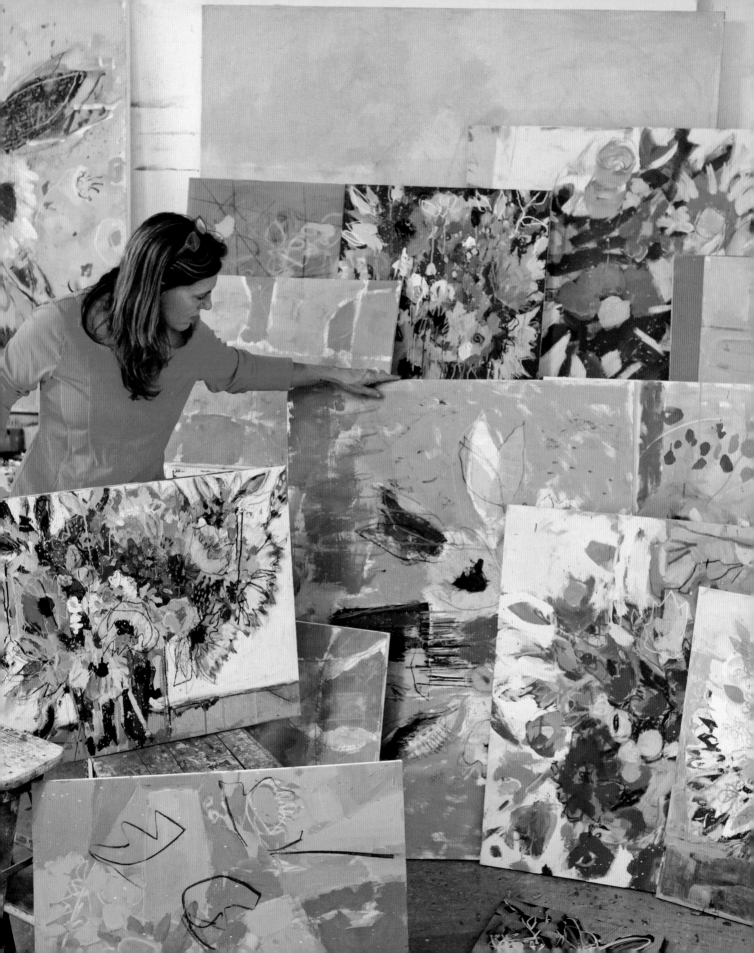

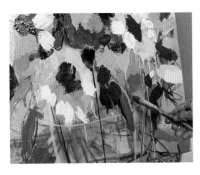
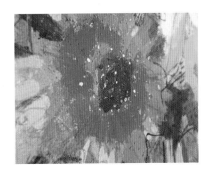
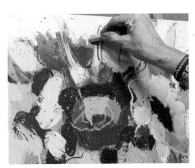

it's only a layer

"And now go, and make interesting mistakes, make amazing mistakes, make glorious and fantastic mistakes. Break rules. Leave the world more interesting for your being here. Make good art." —Neil Gaiman

Working in layers is 100 percent forgiving, which encourages freedom. Knowing that it is "only a layer" allows you to draw and sling paint with wild abandon. Try anything. Express and explore. You are wide open and willing because you know that you can always cover it up. Why? It's only a layer! Brilliant.

Every drop of energy that you pour onto your page or canvas is the perfect response. Each "in the moment" choice will lead to the next brush stroke and the next free-flowing line. Layers build organically, get partially covered up, and create interest, depth and mystery.

Working this way allows you to be fully alive in your painting process. You will find unexpected shapes and new colors. Delight in exciting, fresh combinations of line, shape, and mark. Discover new solutions, knowing that each layer will inform your next move. Move quickly, as curiosity pulls you forward. Add layers of expressive drawing for energy. Lay down lyrical lines that overlap the shapes below. Make marks and add more layers of paint. Play with drips, spatters, and scrapes. You will notice a sophisticated abstraction emerge in your paintings as you listen to loud music, dance, and sing. Layering lets you put your emphasis on freedom and artistic flow. Plus, it's big fun!

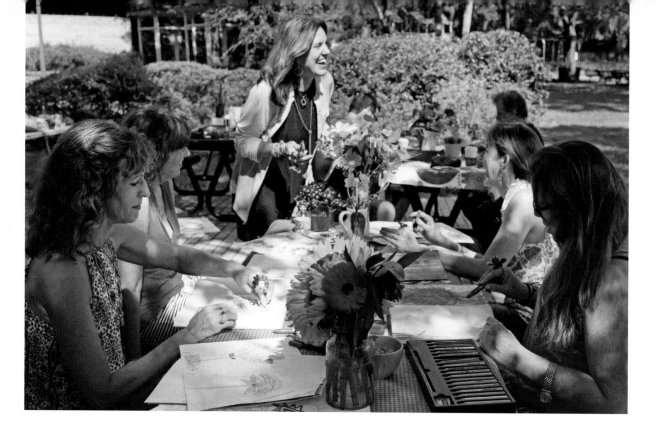

how much fun can i have?

"I like nonsense; it wakes up the brain cells." —Dr. Seuss

What if you constantly asked yourself this question: "How much fun can I have?" This is a powerful, joyful way to engage in your life and your art practice. Great satisfaction comes from finding fresh combinations and learning something new. Creating, at its best, is a beautiful game of play, discovery, and response. The very mark or brush stroke that you put down last will affect what you put down next, and since everything is "only a layer," there are no worries. You stay in the moment and have fun in the process. YES!

Years ago, I wrote "how much fun can I have" on a piece of paper and taped it to my mirror. Every morning I would look at it and giggle. Soon I began to make my daily decisions with that question in mind. I took the same approach to my art studio and things became less serious and much more playful. Give it a try and see if you don't feel extra vibrancy and energy. Soon you will find yourself happily making marks, creating color, drawing with both hands, and joyfully painting with abandon. Turn up the music and move your entire body. Celebrate color and design. Freely create forms and shapes. Make expressive chaos and then

organize all of that delicious "juice" into something new, pleasing, and exciting. Why not?

How much fun could you have if you challenged yourself to use materials in a completely different way than they are intended? Perhaps you decide not to read the instructions? Heck, what if you did an entire painting with just your hands? What if you gathered your friends, family, and art supplies and everyone laughed and made things around a big table? How much fun would it be if you all created tiny, artful offerings and hid them in nature as a free gift to the world? Would it be fun to draw fifty individual flowers, cut them out, and offer them to a friend in a beautiful bouquet? Ask yourself "how much fun could I have if _____?" Fill in the blank—remember, anything goes!

expanding artistic flow

"Art enables us to find ourselves and lose ourselves at the same time."
—Thomas Merton

To be lost in the artistic moment is a truly glorious experience, one of the great joys of life. Have you ever completely lost track of time and forgotten to eat? When you find yourself in this state, it is as if your painting is magically being born before your eyes. Your mind is happy and engaged. Your thoughts and hands move together at the perfect pace. You know exactly what to do next as you are swept forward, fully alive, both calm and excited. Pure bliss!

I deeply believe that we are all meant to move our hands, create, play, and share. We are designed to have our ideas travel naturally through us. The more we "get out of the way," the more our sparks can fly and do their brilliant dance.

Spend more time in the artistic moment by working in layers, removing the feeling that things are "precious." The energy that you put down on the canvas is only there to play off of, so you move forward, responding freely. Listening to music that speaks to you gives you buoyancy while you work. Choosing the paint colors that reflect your personal palette will help you stay present as you dip your brush into paint without hesitation. Simple things, such as choosing bigger, less expensive brushes for painting under layers, will allow you to move abundantly, larger and looser. Come to your "create space" with an attitude of joy and discovery, and your artistic moments will be full, playful, and plentiful.

celebrating instincts

"In art as in love, instinct is enough." —Anatole France

Your instincts are enormous! They are glorious and 100 percent perfect. Pure gold. Listen to those little nudges and knowings that speak to you during your art practice. As you follow your inner sparks, your personal style is revealed with ease. The word intuition is defined as "the ability to understand something immediately, without the need for conscious reasoning." Trust yourself and your artwork will ring true. Celebrating your special, one-of-a-kind voice and following your instincts is like tapping into your very own, artful super powers!

Take note of your personal preferences. Notice the colors that you automatically reach for. Become aware of the natural palette that continually shows up in your wardrobe. Write down the tools that you enjoy using the most. Consider the way that you like to set up your paints, the textures that speak to you, even the time of day that suits you best. Your favorite things are important, and being keenly aware of them will help you make effortless decisions as you create. Knowing the things that you don't love will help you identify what you love the most. The great news about fearlessly trying new things is that all the information you collect will help you create new preferences.

If you are creating, drawing, or painting and you feel a bit stuck, honor your instincts and take a break. Get up and move around. Breathe deeply and take a walk outside in the fresh air. Have a cup of coffee, and perhaps, if you are like me, enjoy a nibble of chocolate. Heck, even check your phone. It is extremely helpful to stop occasionally, pull away, and come back refreshed, able to see your work with new eyes. When you are in the moment as you work, let it flow and enjoy what's happening. If you feel some resistance, gently pull back. It's all a perfect part of the process. Even when you are not moving your hands, your brain is still problem solving. The famous painter Willem de Kooning, who is known for extraordinary energy in his work, said that much of his time, when not moving wildly at the canvas, was spent sitting in a chair across the room, smoking a cigarette, quietly contemplating his paintings. Celebrating your instincts will bring a beautiful balance and satisfaction to your creativity, and to your entire artful life. Win-win.

filling the cup

"Always be on the lookout for the presence of wonder." —E. B. White

Have you ever felt uplifted by breathing in the beauty of fresh flowers? Daily life presents us with many opportunities to "fill the cup." A quiet trip to the market can be unexpectedly inspiring, particularly the produce department, overflowing with the bright colors and organic natural design of vegetables and fruits. Joy is experienced in the textures and aromas of baked goods, in the smiles and interactions of the shop keepers and patrons.

What an extraordinary human gift to be able to take in sights, sounds, and smells and filter them through our personal senses and create a response. As artists, we see the world in more detail and vibrancy than most. We get filled up by a museum visit, a nature walk, or spending time with a loved one. A coffee break can delight, as we savor the fragrance and contemplate the warm cup in our hands.

We are constantly gathering experiences that will spark our lives and our work. Travel gives us ways to soak in different cultures, try delicious flavors, see new things. We open up to a new idea, and set off in an exciting direction. We savor, enjoy, contemplate, celebrate, or simply sit still. Taking time off to fill the cup is invaluable; it keeps us fresh so our creating can continue to process, translate, and transform our world. Expressing through art heals, illuminates, and inspires, not only for ourselves but for others as well.

blue skying

**"If you don't have a dream, how can you have a dream come true?"
—Jiminy Cricket**

What if there were absolutely NO limitations, time restraints, worries, or shortages of resources in any way? Picture having all the help and support in the world. The entire universe is there for you, encouraging you, ready to supply you with each and every whim. Anything is possible. This is the brainstorming game we call "Blue Skying"!

Blue Skying is a marvelous way to grow your dreams. To expand beyond things you never believed possible. To playfully think big and bold. It's a great way to have fun with a dear friend as you go back and forth with pen and paper: What if we did this . . . or that . . . what I have always secretly hoped for is this. Say to yourself or each other "I am just Blue Skying here, so this might sound a little crazy, but what if . . ."

Take about fifteen minutes and a sketchbook and start to crack open lists of possibilities. Be as wild as you can on whatever topic gets you excited. What would your perfect art studio look like? Dream wide, dream tall, dream big! Absolutely anything is available to you. Your world is brimming with ways to make things happen for you and putting it down on paper is not only a great joy, but an important step in turning these things into reality. Sharing your deepest desires with a friend or family member has deep value. Allowing your ideas to come out and play is a beautiful part of the creative process.

Design your one-person show in a gorgeous museum. Plant a giant garden so you can paint it. There are no limits in the big, beautiful, blue sky. Write a book! Name your first child! Create a loving community of inspiring kindred spirits. Dare to think bigger than ever before.

Does your dream sound like laughter, music, children playing? What is under your feet? Is it soft grass, sugar sand, a snowy mountain trail, a city path? Write quickly as your thoughts fly out of your pen, the more details the better. What time did you get up, who is bringing you breakfast, how is your day unfolding? Do you make art, sing, dance, take a nap? These new knowings will light up your bright future. Dream joyously—with Blue Skying, anything is possible!

art supplies

Collecting art supplies is one of the great pleasures of being an artist. Trying new tools, colors, materials. The possibilities hold such promise. Remember when you were a kid starting school with a shiny new notebook and cute pencils? I get giddy just thinking about it. Give yourself lots of permission to have whatever you need in your studio. That abundant art supply feeling will come across in your work. It will free you up to have more fun in the moment. You may have already gathered lots of wonderful art goodies, favorite paints (see page 31), brushes, and markers, but if you are like me, you will keep on hunting for fun new things to try.

favorite supplies

Canvases. I love to work on stretched canvases that are already primed or gessoed. Having a stack of canvases ready to go makes it easy to jump in and create whenever the mood strikes. Sizes that will come in handy are 12 x 12 inches (30 x 30 cm), 11 x 14 inches (28 x 36 cm), 24 x 30 inches (61 x 76 cm), 36 x 48 inches (91 x 122 cm), all the way up to 48 x 60 (122 x 152 cm). Choose a size and format that works well for you. You should be able to find a 50-percent off sale, which would be a good time to stock up. I highly recommend working on several canvases at once, which will keep you moving quickly from painting to painting, taking turns as each one dries.

Chalk Pastels. Collect a nice assortment of "soft" chalk pastels to choose from when you draw. Go for colors that speak to you and excite you. Pastels come in a wide range of options, from very inexpensive all the way up to super, pigment-rich, hand-made pastels that are sold individually. Having a combination of different brands helps you define your perfect preferences. It's fun to discover the nuances of softness, hardness, color, feel, and so on. I cannot go into an art supply store without coming out with a few new pastels!

Oil Pastels. Oil pastels are a great option. They are rich in color and texture and are especially wonderful for the top layer of a drawing because they do not require a spray sealer. They have a special feel against the canvas or paper that you might love. A note to remember about oil pastel or oil paint is that it works beautifully on top of acrylic paint, but acrylic paint doesn't work well on top of oil paint; so as long as your final layer is oil, you should be in great shape.

Markers. Oh the gigantic joy of a big selection of colored markers! All of that delicious color, right at your fingertips! I have a ton of different types of markers, from Sharpies to Tombows, from water-soluble to permanent. Some projects might call for archival permanent markers, others for a thin, thin line. You can work with the wonderful brush tips for a wide line; others are ink based. There is a beautiful world of markers to explore; find and collect your personal favorites.

Charcoal, Pencils, and Graphite Sticks. All three of these tools are wonderful for drawing and mark making. I recommend using vine charcoal, as it moves well on any surface and wipes out easily so you can try different designs and make changes if needed. A soft lead pencil is a must-have in any

studio; the simple, poetic line that you can achieve with a pencil is timeless. Soft lead smudges nicely, which will add a great halo effect to your line. Look for a pencil labeled 3B or 4B. A graphite stick will also give you a lovely line, but with a thicker tip.

Brushes. I am a huge fan of working with a wide array of brushes, from the lovely, long-handled brushes found in the art store to the inexpensive "throw-away" brushes. Variety is key: small "rounds" for details and 1-, 2-, and 3-inch (3, 5, and 7.5 cm) hardware store brushes for painting your under layers. A bigger brush will keep you moving quickly, with a tad less control, which is great.

Matte or Gloss Acrylic Medium. Acrylic mediums in a matte or gloss finish are great for gluing down collage elements. They make colorful painting glazes when you use them to thin down your acrylic paints. When collaging with tissue paper, I prefer using a fluid gloss liquid medium such as the Liquitex brand. If you have a thicker gel medium, you can thin it with water to achieve a more watery consistency that works perfectly. Mediums can also be a final "brush" coat for your work.

Tissue Paper, Rice Paper, and Collage Paper. Collaging with paper not only adds a great layer of shape and color, it also adds texture. You can put down the bones of your painting in an early layer and build on top. Tissue paper is fun because it often becomes partially transparent when glued down. You can use found papers such as old ledgers, maps, or pages from books. Rice paper is great to draw on with markers and incorporate into your collages. Some papers might bleed color when they get wet, but since we know it's "only a layer" there is no problem at all. You can choose papers that are non-fade, but most of your early layers of collage will be covered up with gloss medium, paint, and pastel. A

rule of thumb in any art project is to choose materials that give you the most confidence.

Sketchbooks. When it comes to sketchbooks, the more the merrier. They come in lots of different dimensions, numbers of pages, types of paper, and paper weights. I recommend a size of 11 x 14 inches (28 x 36 cm) or larger so that you have lots of room to move and be free when you draw. If you are working with water medium, you will want a thicker "mixed media" paper that is usually 98-pound or higher. A super smooth choice, and one of my all-time favorites surfaces to work on, is Bristol paper, which comes in pads. Each page is bright white and has a nice 100-pound thickness. A sketchbook is the perfect place to doodle, think, draw, make lists, collect ideas, dream up intentions, do your "Blue Skying" brainstorming, create your seed drawings, and more. Invaluable!

more on materials

"Don't overlook some of the best tools you have in your possession—your fingers and hands." —Earl Grenville Killeen

There are many more tools and simple items that will make your art practice run smoothly. Having these basics in your "create space" will be a plus. For many years, I ruined every pair of scissors that came across my path. I worked so spontaneously that one minute I would be using my nice, new sewing scissors to cut fabric and seconds later I would find myself using the same scissors to cut a piece of steel wire—yikes! My scissors were beat up and covered with paint. Sadly, I learned that scissors with raggedy edges do not work well, even on paper. It took me a while, but I finally got organized and put the tools I needed in a place where I could quickly find them. We all have different needs and our own personal approaches to organizing. I have found a basic idea that works well is to gather like things together. I put brushes with brushes, markers with markers, and paints with paints. I even have crummy, old scissors with crummy, old scissors and nice scissors with nice scissors. It helps!

materials that help keep my creative practice going strong

Fresh Flowers. Since I paint and draw mainly from fresh flowers, I have many vases, pots, and buckets for various arrangements. I love the act of arranging flowers and often have three, five, or more fresh bouquets in the studio. I also have some silk flowers that I can refer to if my fresh flowers are, well, not so fresh.

Light Source. A simple lamp or light is very helpful for seeing the form of a flower by using the light side and shadow side. I would be lost without a good light source. Light not only helps us see but also helps us look, which helps us draw and paint!

Music. One of the most important things I have in my space or anywhere I paint is MUSIC! I encourage everyone to use energetic music to inspire their art making. Any kind of movement or dance while you are painting adds joy and freedom to your process. I listen to all types of music as well as podcasts or Ted Talks. I use a small, portable speaker and my smart phone.

Camera. If you take photos of your paintings in process, you will be able to see what is working in your composition and design. And you can share them with your trusted art pals, collectors, and on social media. Another great use of the camera is to capture images of your fresh flowers with your light source. Photograph them in all different states from full bloom to beautifully wilted, for future reference.

Rags and a Water Bucket. Rags come in handy every step of the way. I can't imagine working without them; the soft t-shirt kind are my favorite. A good water bucket is an important studio staple. You want one that holds enough water for your needs and accommodates long and short brushes without tipping over. My not-so-attractive water bucket holds the perfect amount of water, and I fill it exactly the same way every time I paint. It has become a ritual.

Scissors. Purchase a few really nice pairs of scissors. If you spend a little extra money, you will take good care of them. There is something so satisfying about an everyday tool that works perfectly. Here is to your nice, new scissors and the extra joy that they will bring to your day. Snip snip!

Spray Fixative and Spray Varnish. It is important to spray seal your pastel and charcoal drawings to keep them from smudging. Read the directions, give your work several coats, and be sure to let them dry in between sprays. Be safe: Do all of your spraying outdoors or in a well-ventilated area. I give my pastels the "pinky test:" After I spray seal my canvas, I rub my pinky across the pastel until no trace of color comes off.

Basic Tools. Have at your fingertips a decent hammer, some nails, wire, wire cutters, pliers, staple gun, staples, drill, screws, measuring tape, ruler, and whatever other goodies you know you need. By taking good care of your art practice and the needs of your studio, you are giving a great gift to yourself. You deserve a happy, healthy creative space.

Pipe Cleaners and Other Fun Things. Having a few materials in your studio for no other reason than to encourage play makes for a happy, playful experience that helps get the creative juices flowing.

fresh color

"Use lots of paint and don't worry, they will make more." —Richard Schmid

Wonderful, gooey, beautiful, playful paint! Just looking at paint makes me excited. The idea of moving color around is beyond inspiring. I used to joke with my outdoor painting partner, Don, that I was going to devote my entire life, every fiber of my being, to color. Acrylic paint works well because it is water based and easy to work with, and it dries fast and cleans up with little effort. You can change the thickness by adding water—mix the color quickly and create yummy drips and spatters. Acrylic paint comes in tubes or jars and in various price ranges. Find a combination of brands that works best for you. You want your paint to feel wonderful on your brush and canvas. I enjoy working with many of the brands of paint found in the art store, including the luscious Golden brand. I might mix in some flat hardware store paint as well. I prefer working with paints in jars as they make it easier to stay in the moment. You can quickly dip in your 1-inch (3 cm) brush and keep moving and mixing color.

some notes on color

- Warm colors are often referred to as the colors of the sun. Think of things that are hot, such as yellows, reds, and oranges.

- Cool colors are the colors of water and shade. Think of cool blues, greens, and violets.

- Painting with an under layer of neutral color will pop vibrant tones that are put on top.

- Push a color to the warm side by adding some warm colors to it and to the cool side by adding some cool colors to it.

- Warm and cool grays make great neutral colors.

- Think of value as a gray scale ranging between lightest lights and darkest darks, with the mid-toned values in the middle.

- Vibrating colors happen when you put a color's opposite next to it, such as a green next to a red. The more you play with this idea, the more you will love it. Our eyes enjoy that extra little zing that makes our paintings more alive.

- Mixing color is a great pleasure. You'll learn as you go. If you make "mud," no worries: You can use it as a neutral color.

- Hang a color wheel in your studio space near where you paint so you can refer to it often.

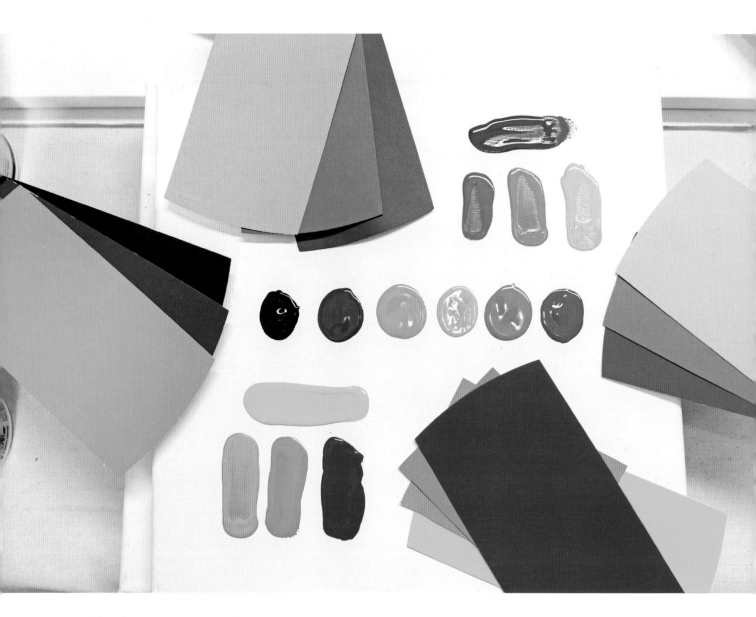

When buying paints, get at least three of each primary color—red, yellow, and blue—in a light, a mid, and a dark tone. I pick the colors I personally like so it keeps me smiling when I paint. I love to add a few secondary colors, such as a vibrant light and dark green and a wonderful hot pink as well as a bold orange. Round out your paint selection with a super dark gray and a very bright, clean, warm (to the yellow side) white. I also like to have a light and mid warm gray and a light and mid cool gray. Usually, I will be dazzled by the many beautiful paint colors available and grab a few extra, yummy colors just for fun.

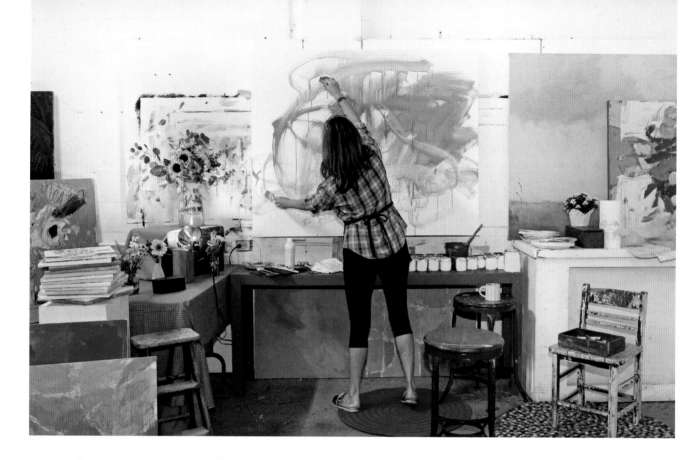

work space, reflecting space

Fill your personal "create space" with the things that you love the most. Your colors, your textures, your artwork. Dedicate some wall space for drawings, paintings, and works in process to keep your mind sparked and excited. For years, I have filled my studio walls with small bits from nature, pinning up a leaf, a feather, or a smooth, painted rock tied with a waxed string. Create a space to nurture your specific creative spirit. A studio can also be a place to show your work and hold workshops if you desire, but mostly it is a place to do the thing you love with ease and joy.

Be sure to make a cozy spot where you can sit quietly, relax, and fill the cup. Take breaks. Look at your work from a distance. Read or research. Have a little bit of chocolate and just consider your paintings. There will be countless wonderful moments in your studio; many will be when you are dancing and moving your hands and others when you are sitting back and quietly considering what you have made. That comfortable time spent solving problems is an important thinking time. All studios need a quiet spot to gather information, listen to your instincts, and move back into the process.

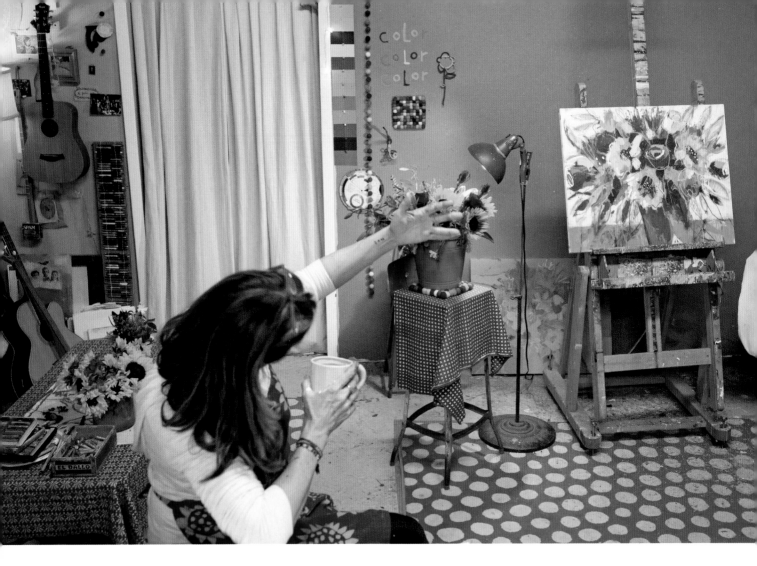

things to consider for your studio

- Lighting is key for seeing your canvas and color as you work. Choose overhead or directional lighting so you can see well without shadows. If you have windows and north light, fantastic.

- Your painting space will include an easel or set-up on the wall for working on your canvases. You will need a table for paints and a water bucket, plus another table and light source for your flowers. Consider the height of your paint table if you prefer painting standing up, so you can smoothly move and dip your brush into paint. You want to easily flow during painting.

- Fresh air, a fan, ventilation, or an open door to the outside is beneficial. Fresh flowers in your space are nourishing and positive. Live plants in your studio bring additional joy and life.

- If possible, set up a painting station outside occasionally. Being near trees and nature and working under the big, blue sky is inspiring.

- Storage for supplies, canvases, and other things can come by way of book shelves, bins, baskets, rolling carts, and drawers.

- You need a comfy area to sit at a distance and look at your works in progress, read, soak in

inspiration, fill the cup. An outdoor spot to sit and take breaks is very nourishing as well.

- Your worktable is a great place for drawing, collaging, painting, arranging flowers, sketching, and hosting friends. Mine is covered with brown paper, so there is no worry about getting it messy; I encourage everyone who visits my studio to draw on it. You can cover your table with a festive cloth, candles, and refreshments for visitors. I have several tall stools around my worktable that come in handy for workshops, gatherings, songwriting, and playing live music.

- I recommend a "slop sink" nearby for cleaning your brushes; they are made for big commercial jobs, so they are deep enough for rinsing and filling large paint buckets. Plus they take away the worry of keeping a nice sink pristine.

- Music! From small portable speakers and a smart phone to giant speakers and a turntable, use whatever you can to play music or anything you love to hear.

simple studio solutions

Studies have shown that preparing a dedicated studio space sends a message to your brain that your creativity matters. You don't have to have everything in pristine order to make it happen. Some simple solutions will get you moving your hands in whatever space you have available.

Clip Lights. As mentioned, a light source is important to help you see the forms of your flowers while painting and drawing. If your studio space doesn't get natural light and a table lamp or a standing lamp won't fit your needs, invest in a small clip lamp from the craft or hardware store. One of my favorite solutions, these types of lamps are lightweight and easy to position to illuminate your beautiful blooms.

Paper Plates. Paper plates are the perfect, affordable, and reusable paint palette because they are lightweight and can be used over and over. I quickly found several more uses in the studio for them. When you have a collection of chalk pastels that you are working with, you will find that they leave quite a mess in whatever dish you use. By putting them on paper plates, you can easily hold the pastels on the plate with one hand while you draw with the other.

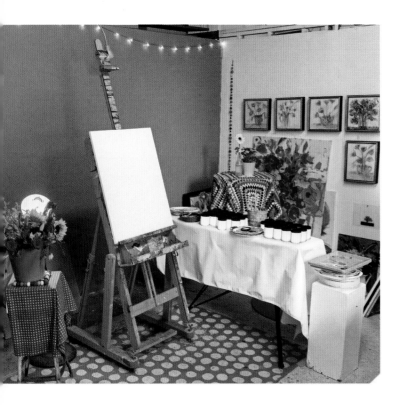

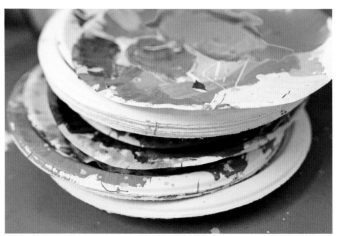

I have plates that are filled with just markers, some with colored pencils, and others with jars or tubes of paint. I find that I can stack up three or four plates of pastels, drawing tools, or paints, helping me keep organized. When the plates get messy with chalk pastel dust, you can simply roll the pastels onto a clean paper plate and place the used one at the bottom of the pile.

Cinder Block. Putting a cinder block against the wall works well as an easel. It is good to get your painting off the floor and higher up so you can paint comfortably. For large paintings, I often place the cinder block on a table against a wall. It is a simple solution and one I have used for years. Many great artists in all types of studios work large canvases this way. Another option if you don't have an easel is to work your canvases flat on a large table.

Chair. You will find that a chair up against the wall also works as well if you need an additional easel while working on more than one painting at a time.

Drop Cloths. Old blankets or sheets will work fine if you need to cover floors or walls in your work area. Painting, spattering, and dripping can be messy business. I have had some students tell me that their husbands are a little surprised to find flecks of paint on the walls and windows. Whoops! I would hate for them to see my shoes, my hair, even my dog, occasionally. You can purchase drop cloths or plastic sheeting in the paint department at the hardware store. Another solution is to use inexpensive throw rugs under your easel area. Not only will it protect the floor but will also give your feet a little extra comfort.

redefining play

"Play is our brain's favorite way of learning."
—Diane Ackerman

Have you ever thought about the relationship between humor and creativity? That special spark that instantly lights up your face with a smile?

Be on the lookout for a brain surprise, that unexpected jolt of happiness when you are confronted with something new, while you are working in your studio. The best way to accomplish this is to spend more time in play mode. Think of your art practice as a creative romp, a wonderful pastime. As you approach your painting, drawing, and art making with this childlike state of mind, you are setting yourself up for interesting problem solving. Intuitive responses come easily when you look for delight and laughter.

I love the following quote from David Bowie when he was asked about the creative process for the 1997 documentary *Inspirations*: "The other thing I would say is that if you feel safe in the area you're working in, you're not working in the right area. Always go a little further into the water than you feel you're capable of being in. Go a little bit out of your depth, and when you don't feel that your feet are quite touching the bottom, you're just about in the right place to do something exciting." Yes!

warm-up and creativity exercises

2

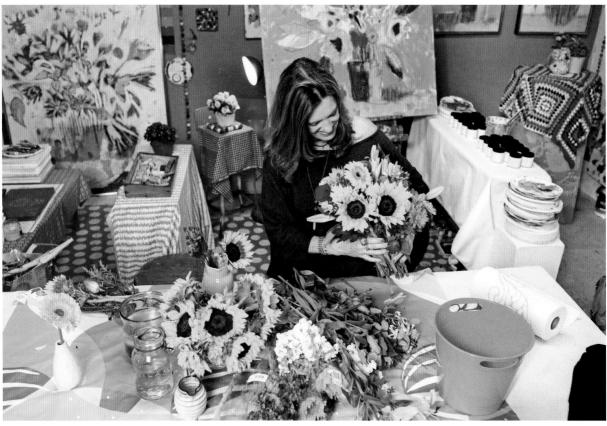

Choose a variety of vases and flowers.

artfully arranging beautiful blooms

"When you unleash your creativity, a whole new world opens at your feet. The sun becomes brighter and the birds sing louder. Like a child running free at recess, you laugh, run, and explore, thrilled to be alive." —Tess Marshall, *Flying by the Seat of My Soul*

Painting and drawing bold blooms will give you a fantastic excuse to fill your space with fresh flowers. A bright bouquet or one simple blossom will bring beauty to any room. Flowers have a special way of bringing a smile. Time spent arranging and preparing your flowers is a gift to yourself. Enjoy combining colors, organic shapes, textures. Being swept up instantly by the many miracles of natural design and instinctually gathering your blooms together in an artful way. This makes me happy just thinking about it. Do it your way, it will be perfect.

Include a nice assortment of greens for texture.

arranging blooms for drawing and painting

- No matter where you find fresh flowers, whether it be your garden, a nearby field, an outdoor market, or a flower shop, always choose your favorites. If there is something new that excites you, go for it. If you are crazy about sunflowers (I lovingly call them "sunnies"), grab a bunch. Feel abundant. Be excited by the colors and variety you gather, some bold, some tiny, some vibrant, some pure, some soft. Fill your arms with a bounty of blooms and carry them home with glee.

- Collect some lovely greens to fill out your bouquets. Look for branches, berries, ferns, heather, holly, ivy, eucalyptus leaves, Bells of Ireland, myrtle, moss, and more. Greens are wonderful to study and draw on their own. Spread them out in a line on your work table and make sketches. I often pin a variety of greens directly to my studio walls for beauty and inspiration.

- Use vases and vessels in different shapes and sizes. A vertical painting may be best done using a vertical vase. A decorative pattern on a pot may inspire your painting. Consider using a glass vase so that you can see the stems and the reflections of the water, as they make incredible design elements. I often have several fresh arrangements in my studio at one time. I glance at all of them, borrowing a few ideas from each if I need to fill in my painting. Abundance! Always!

- Turn on the music and enjoy a mini celebration as you arrange your blooms. Take your time, dance, soak in the beauty and smells. You are designing the main event of your painting, your muse. Play with large and small shapes; choose a few tall, thin verticals, consider a pleasing color palette with darks and lights. Stand back and gaze at the

Glass vases allow the stems to become part of the design.

Create some full arrangements and some with space between the blooms.

overall shape. Add a few leaves or blooms that hang over the front edge of your pot or vase. I always ask my flowers what they need as I spin the vase and look for their best side; they are always happy to help.

- Research different flower meanings. Flowers have been used to communicate emotions and tell stories for hundreds of years. I loved learning that the Gerbera, a part of the daisy family, conveys cheerfulness. Sunflowers are said to represent warmth, adoration, and dedicated love. Perhaps there is some hidden inspiration behind the meaning of your blooms that can make its way into your paintings.

seed drawings

My favorite teacher, New York illustrator David Passalacqua, was so keen on seed drawings, which he called thumbnails, that he insisted we do pages of them every day, before anything else. These small drawings warm up your thinking and hands. They push you past the first four or five obvious choices toward a design that is more nuanced and dynamic. I have a blind spot when it comes to putting things smack in the center of a canvas. Seed drawings help me see the entire design and make those tweaks early on. Begin by putting down square, rectangle, or horizontal shapes to draw in. Your mighty sketchbook is the place to make these tiny "painting maps" as you try out different options before you commit to an actual painting. Approach these freely as you loosen your line, and hone your composition skills at the same time. Perfect!

materials

Sketchbook

Assorted colored markers

Pencil

Flowers in vase and light source

Music suggestion: classical or upbeat instrumental

Individual seed drawings

how it works

1. On a fresh sketchbook page, draw several horizontal shapes. Begin to loosely sketch in your arrangement. Working within the format of your canvas shape will enhance your compositions as you will be able to see the negative shapes. Hold your pencil or marker loosely and move quickly. Change colors. There is no pressure; you are just trying on ideas.

2. On another page draw several vertical shapes. Use your seed drawings to design your vertical painting inside of that shape. Move fast, and surprise yourself with your small painting maps. The more you do the looser you get. Continue to look and draw the same arrangement over and over in the different formats; feel the editing and shorthand effortlessly happening.

3. Now create square boxes on a new page and draw your flower arrangement inside that shape. Let some of your leaves grow and spill off the edge. Add small marks to create atmosphere.

4. Putting down the dark areas in your arrangement with a thicker marker will help you see the structure and the bones of your possible paintings. There is a really great thing that happens in your design when you can see the darker areas, as it helps you see a structure for your blooms.

5. As always, every layer and process is all about you. Please take note of the things that appeal to you most. Do you prefer horizontal or vertical? Is a square the perfect proportion for your designs? Make notes and have fun!

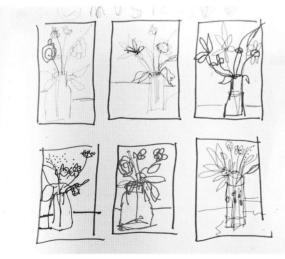

Put seed drawings inside of a format.

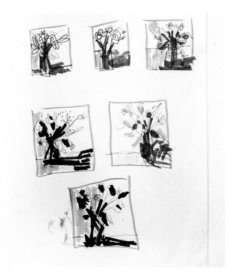

Add darks with markers to show structure.

two-handed speed drawings with music

"Nothing great was ever achieved without enthusiasm."
—Ralph Waldo Emerson

Two-handed speed drawing is about freely making marks with energy! Pure instinct. This is "in the moment," "get out of the way," "make yourself laugh" stuff. You will be using a timer for fifteen-, thirty-, and sixty-second drawings while looking at flowers. Use both hands and grab the essence of the flower form and put it on paper as fast as you can. Faster! Keep your eyes on the flowers, don't look down at your paper. How much fun can you have as you translate blooms with a speed response? Total fun and it's a great way to loosen up. You will use this method later in your layer by layer bold bloom paintings to keep your line and mark lyrical and alive!

materials

Flower arrangements (fresh, silk, or photo reference) with a light source

Mixed media paper or sketchbook, 11 x 14 inches (28 x 36 cm) or larger

Timer (you could use the timer on your smart phone)

Soft pastels in assorted colors

Markers in assorted colors

Music that makes you happy, giggly even!

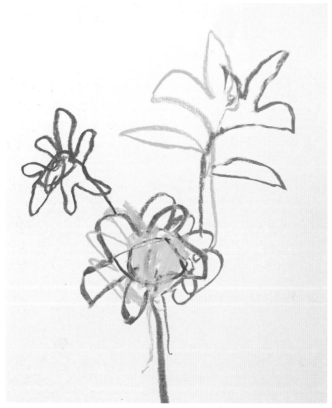

Thirty-second drawing

Fifteen-second drawing

Thirty-second drawing; vase drawn with two hands, showing light and shadow sides.

Thirty-second drawing

Sixty-second drawing

how it works

1. Set up your space with several sheets of paper and a few small flower arrangements with a light source. If you are using photos of flowers, choose a few that have a light side and a dark side. Have your timer, music, pastels, and markers ready to go.

2. Set your timer for fifteen seconds, take a pastel in each hand, and, as fast as you can, put down one flower. Super fast! Stop at fifteen seconds and reset the timer and do it again. Repeat the process at least four to six times, and put two or three drawings on a page. This process will probably make you laugh and feel a little out of control, which is perfect. Draw like a child! Have fun! Be loose and free!

3. Set your timer for thirty seconds, take a pastel in each hand, and go! You might be surprised how long thirty seconds will feel. Focus on one flower at a time and add details such as a stem, a leaf, or more color. Keep going. Reset the timer for thirty seconds per flower, making four to six or more. Move to the music and make a mess; no one is looking, so fully engage and enjoy!

4. Set your timer for sixty seconds. Take a pastel in each hand, look at your blooms, and put them down on paper with energized marks and a lyrical line. A full minute will feel like a crazy, luxurious amount of time after the shorter drawings. Make scribbles, scratches, and smudges. Make yourself laugh knowing that any way you do this exercise is 100 percent perfect. Approach your flower drawings with the curiosity of a child. YES!

5. Next, you will start with a fresh piece of paper and draw one playful, slightly larger version of your vase. Place your drawing near the bottom of the page, either slightly to the left or right, not perfectly centered. Set your timer for thirty seconds, and quickly put down a confident version of your vase. Think of one side being the light side and one being in shadow, letting that show in your color choices. Play!

playful pot of blooms

"The earth laughs in flowers." —Ralph Waldo Emerson

You have created a fresh set of free and in-the-moment flower drawings. Bravo! Now let's take them, cut them out, and create a one-of-a-kind bouquet of blooms. Take your time and playfully arrange them on the paper with your thirty-second drawing of a vase. Once you have taped them to the paper, you can hang your pot of blooms on your workspace wall. Refer to them for inspiration and as a reminder to stay loose and to have fun whenever you are drawing.

materials

Fifteen-, thirty-, and sixty-second speed drawings

Thirty-second drawing of a vase

Scissors

Scotch tape

Music suggestion: bright, light, and upbeat sounds

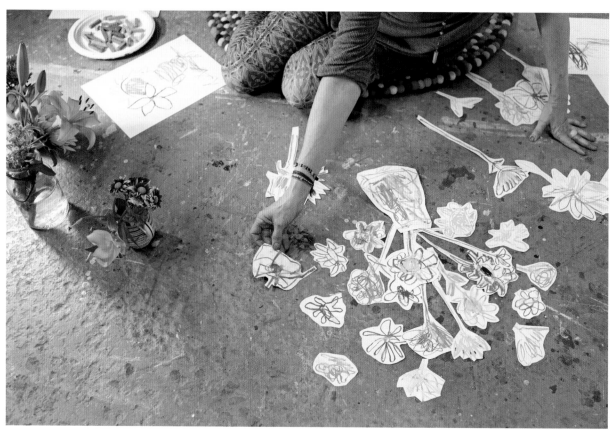

Arrange a bouquet of cut-out flowers.

how it works

1. Cut out each individual flower drawing. Some will have stems, some may not. You don't have to cut them out super closely or perfectly; just go loosely around the edges with your scissors.

2. Spread your flowers out on the table or the floor and take stock of what you have to work with. Try different combinations as you arrange your flowers as if they are coming out of your vase. Follow your instincts and create a fun and fresh arrangement with your freshly drawn flowers.

3. Tape your bloom drawings down in place and remember this is not about perfection; it is much more about joyfully following your instincts and putting great shapes together on the page. Hang your new playful pot of blooms up in your studio as inspiration and a reminder to stay loose and free.

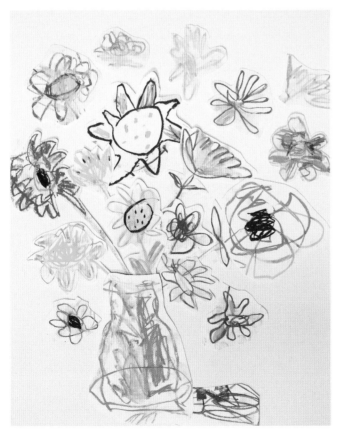

Playful pot of blooms

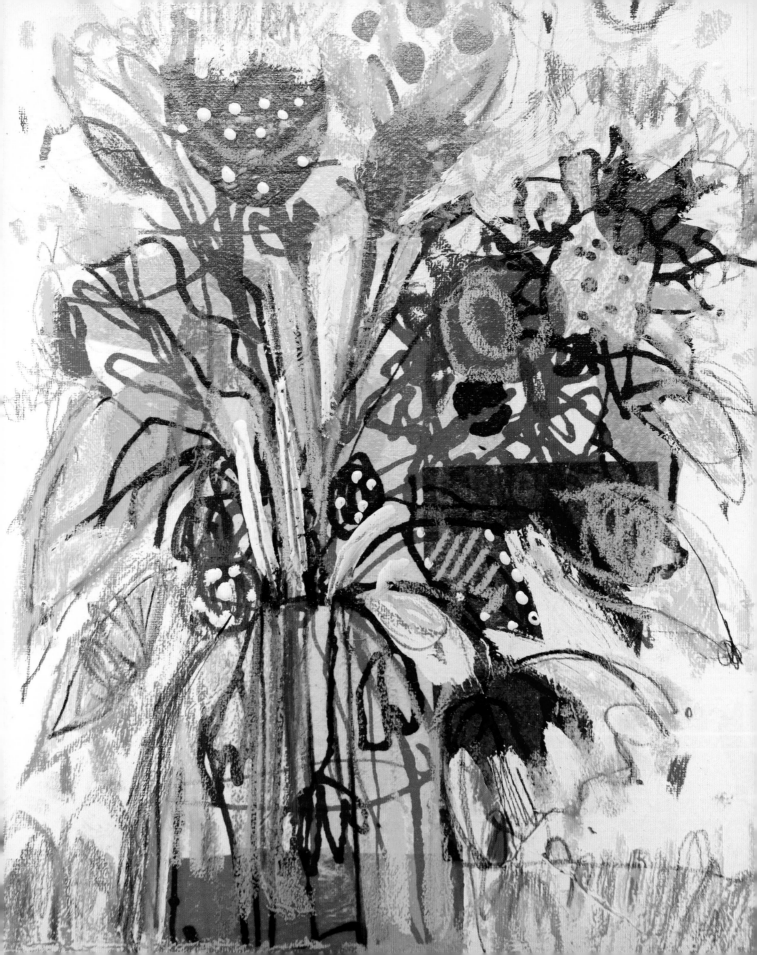

line, shape, mark, color, and collage

Explore the basic building blocks of art making—line, shape, mark, color—using bright blooms as your muse. Collage simple and colorful shapes with tissue paper as your first layer, adding interest and activating the page. Next, your two-handed drawings on rice paper or tissue paper will build a lovely layer of line work. Now play with acrylics as you paint around the edges, creating a large background shape. Excite your entire piece with expressive drawing on top. There are quite a few steps to this project; you could almost have a finished piece on every layer, so feel free to make several pieces, stopping at any step. Do one that takes you through the entire process and know that you can keep adding extra layers.

materials

Flower arrangement

Gessoed canvas,
11 x 14 inches (28 x
36 cm) or 12 x 12 inches
(30.5 x 30.5 cm)

Tissue paper

Scissors

Gloss or matte medium
for gluing (if you use thick
paste, thin it down)

Water bucket

Pad of art rice paper, deli
paper, or light-colored
tissue paper

Colored markers,
permanent non-water
soluble

Acrylic paint, any light
color you like

Brushes

Pencil, soft lead

Soft pastels

Rags or paper towels

Music suggestion: jazz
or something with a
cool beat

how it works

1. Set up a small flower arrangement as your muse. Gather your materials and canvas. Begin by cutting out simple organic shapes of colored tissue paper that will represent some of the forms you see in your flowers: leaf shapes, circles, ovals, and more.

2. Arrange your shapes on your canvas in the loose feeling of your arrangement, including your vase shape. With your matte or gloss medium, glue your shapes down. No worries if your tissue paper tears or buckles—remember, it's only a layer! You will be covering some of it up.

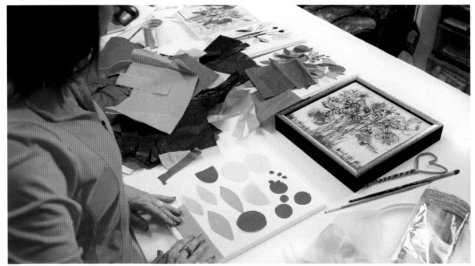

Create colorful
paper shapes.

Cut out a simple vase shape.
Use gloss or matte medium to
glue down paper.

3. Get ready to draw your flower arrangement on rice paper, deli paper, or some of your tissue paper. Use both hands and two different colored markers. Overlap your line, make loose loops, and feel lots of freedom as you work. If you are using rice paper, notice the wonderful ghost drawing that occurs underneath. Cut out your drawing and place it on top of your collage.

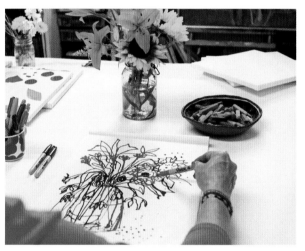

Use both hands to draw your arrangement.

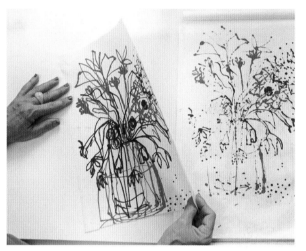

A lighter version of the drawing on the rice paper underneath

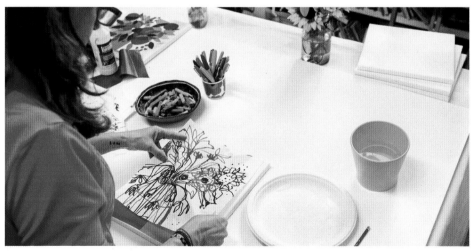

Place the drawing on top of the collage.

4. Collage your drawing on top of your colored paper collage with gloss or matte medium. If you are using a thick paste gel medium, thin it down with water.

5. Using a light color of acrylic paint of your choice, begin "cutting around with paint" to create a new large shape of your flower pot. Enjoy carving in and creating new leaf shapes, enhancing your pot shape, and perhaps describing your table plane.

6. Once dry, add more drawing on the top with pencil, pastels, and markers. Take liberties, and go as loose as you can with your line and mark making. Add your voice, your colors, your ideas to the page. Add energy and juice! Have a blast as you create another playful, fresh pot of blooms in your very original way.

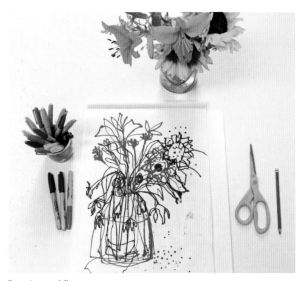

Drawing and flowers as a muse

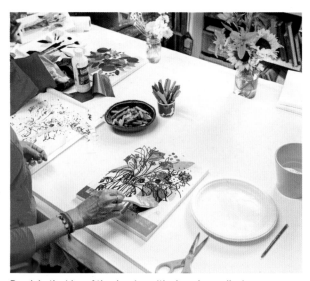

Brush both sides of the drawing with glue when collaging.

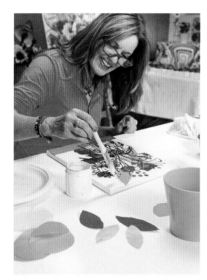

Paint a large shape around blooms.

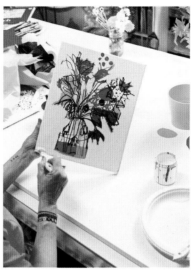

Create a new overall shape with paint.

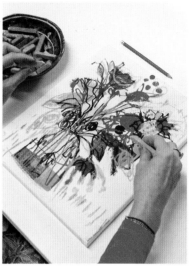

Add highlights with pastels and pencil.

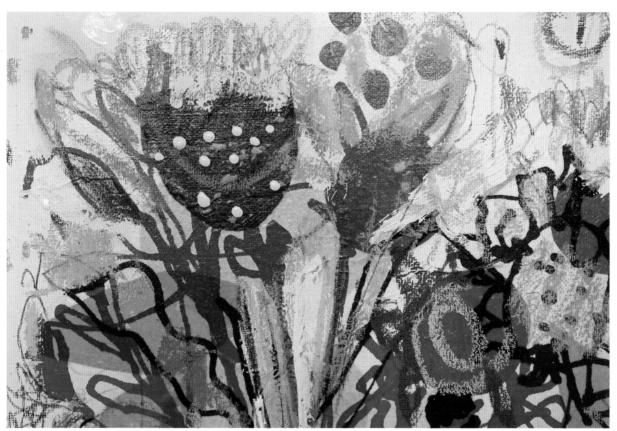

The end result

3
layer by layer

a playful approach
to painting bold
blooms

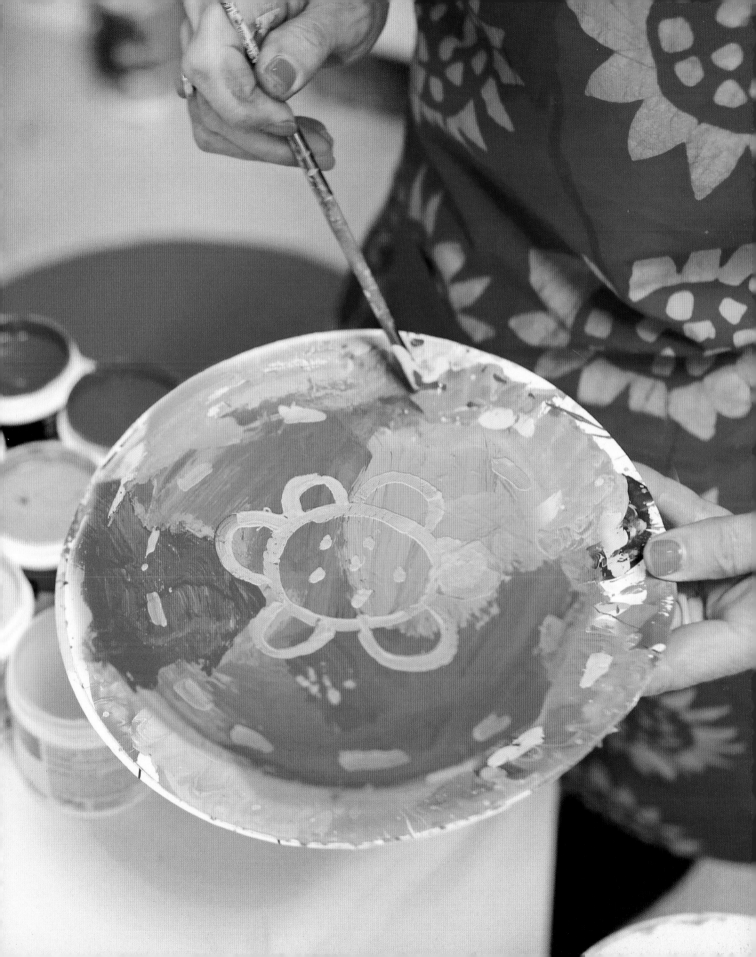

layer one
loose ground painting

It is time to PAINT! This is the beginning, layer one, of at least eight layers on your bold bloom painting. Just knowing that you will be covering up much of this layer as your painting builds will help you approach your blank, white canvas with abandon. The goal is to make this as fun and exciting as possible right from the start. Put down energy and personality in as many free-form ways as you please. Take this opportunity to try new things. Use your brush stroke differently and change your color slightly each time you hit the canvas. Give yourself permission to play with drips. Step back and spatter paint with glee. This loose layer will set the tone for the rest of your painting, as it will peek through each layer you put on top.

Choose a medium cool (blue) gray for your first layer. As we build our layers, we will put the opposite colors on top to watch the colors vibrate. If you prefer, start your ground layer with a warm orange tone. If you choose to work on two canvases, do one of each. Once you start freely applying paint to the canvas, you may want to cover several canvases with Layer One (loose ground color) while you are in the flow. Think of this layer as a wonderful way to warm up and loosen up.

materials

Acrylic paints

Water bucket

Paper plates for palettes

One or two gessoed canvases, 24 x 30 inches
(61 x 76 cm)

2-inch (5 cm) brush

Rags

Music suggestion: dance music! upbeat
and lively!

big idea

How much fun can I have
energetically applying paint
to the white canvas??

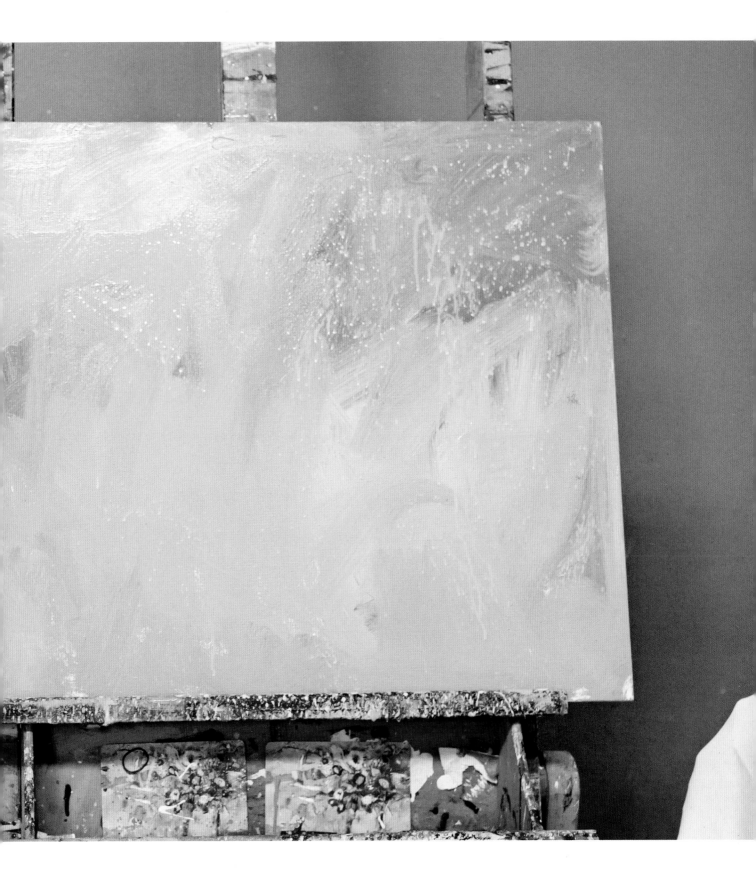

how it works

1. Mix up a nice cool (blue tones) medium gray color. Experiment with thick and thin paint by adding some water. Keep it moving quickly.

2. Go for it! Turn up the music and begin to cover your canvas with the first layer of paint. Think freedom and fun! Paint with your entire body, using big motions with your arms. Stand back and sling some paint.

3. Take time here to really explore all the joyful ways you can move your brush. Experiment as you hit the canvas with a different part of your brush every time. Sloppiness is good here and it's only a layer, so there is no wrong way.

4. Practice your drips on purpose. Lighten or darken the color just a little bit so the drips stand out. If it makes you a little squeamish, do a few extra just for good measure. Spin your canvas just to change the direction of the drips.

5. When you spatter, change the color of your paint slightly. Make your spatter lighter or darker to create a pattern of color.

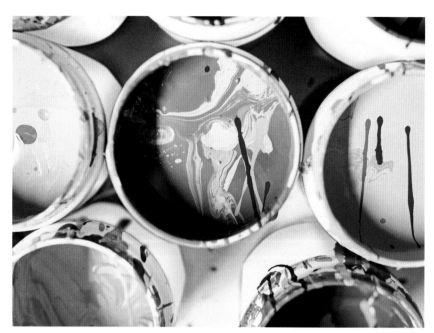

Neutral gray paints

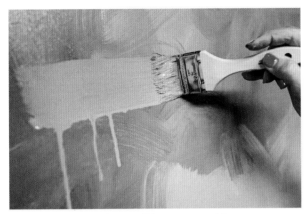

Paint energetically with neutral blue-gray on a white canvas.

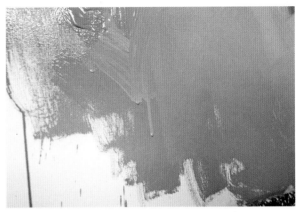

Combine lighter and darker gray together, thick and thin on the canvas.

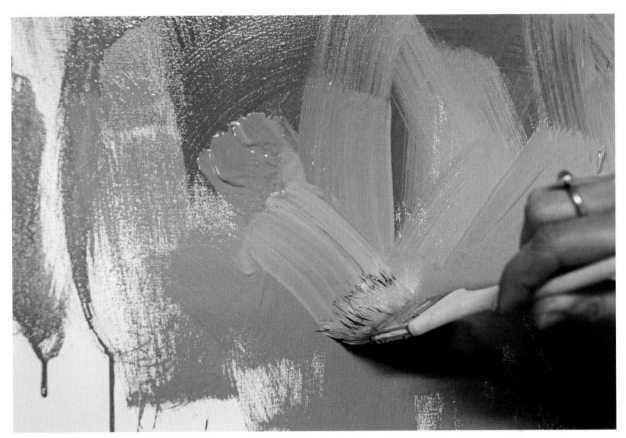

Play with drips, color shifts, and brush strokes.

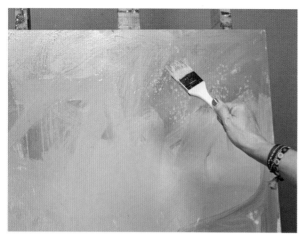
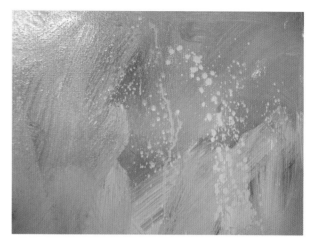

Freely move your wrist and spatter with lighter grays.

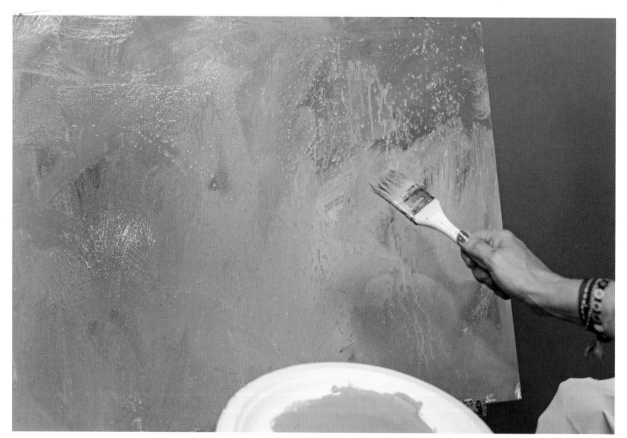

The orange spatter vibrates on the gray canvas.

layer one tips

o Working on more than one canvas at a time will keep your hands moving and your brain engaged. While one is drying, you can keep working on the next!

o Working on two canvases, paint one in a vertical format and the other in a horizontal format; see what appeals to you most.

o Acrylic paints in jars are often easier to dip your brush into, which will keep you in the moment, engaging your instincts and moving quickly.

o Use an opposite color for spattering—try orange, just for kicks. Notice the colors vibrating together.

o For interest, use your paper plate palette to slightly adjust the color each time you put the brush to the canvas.

o While you are having fun spattering, keep in mind that you might get some paint on the walls or things around you—and maybe even on yourself! You may need a drop cloth or some plastic to keep things from getting spattered. (My studio is full of spatter, which I like, but you may want to be a little more careful to not get paint all over your things.)

o The more of your personality and your energy you can get on the canvas, the better. I call it "juice"—put some juice on your canvas!

o Wear an old paint shirt or apron to protect your clothes; you want to feel free and uninhibited. My favorite: a dorky turquoise plaid shirt that belonged to my grandfather. Granddad painted beautiful florals in oil paint after he retired; to this day, when I smell turpentine I always think kindly of him. I love the little spots of oil paint he left on the shirt, and I wear it often for good luck!

Add contrast with opposite color spatter.

layer two
spin drawings

Spin drawings are pure joy! Not only do they let you practice your drawing and looking but, because they will be mostly wiped out and covered up, they are not precious. Look at your blooms and quickly make notes about their forms. Use both hands and two different colored pastels. Lightly wipe off your drawing, spin the canvas ninety degrees, and repeat the process. The best thing about spin drawings is that they will almost effortlessly build up a great pattern on your canvas. The more interest we can add in our early layers, the better. Spin drawings are the only way I know how to get this type of "juice" on the canvas; they are also important because they set us up for the next layer.

big idea

How freely can I draw, study flowers, and practice design on the canvas?

materials

Flower arrangement with light source

Canvas or canvases from Layer One

Vine charcoal

Rag or paper towels

Soft/chalk pastels, assortment of colors

Music suggestion: dance music, something lively that keeps you moving in the moment

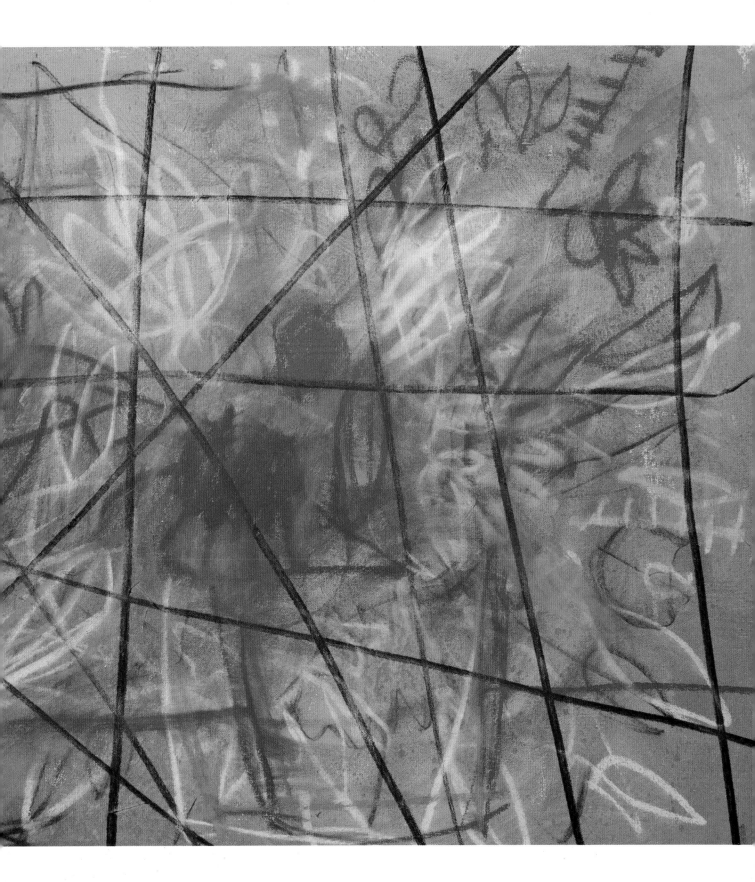

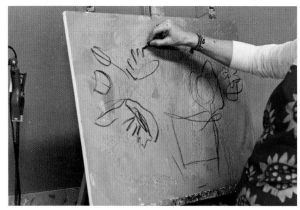

On a horizontal canvas, draw map of flowers with charcoal.

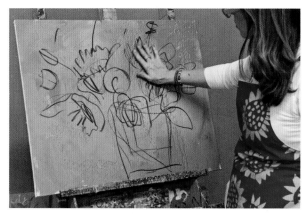

Lightly wipe off the drawing before spinning the canvas.

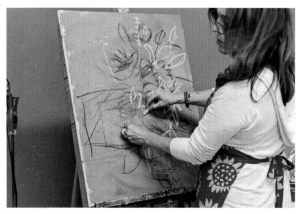

Draw on top of the last drawing.

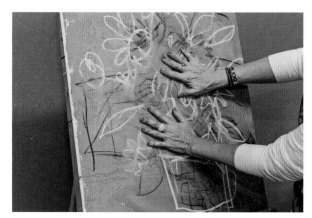

Lightly wipe off the second drawing.

how it works

1. Set it up a flower arrangement and light source to use as your muse and model. On your Layer One canvas, use vine charcoal to make a nice sketch of your arrangement. This first drawing is a just a warmup. Play with where you will place your pot of blooms and make visual notes of the dark areas. Spend only a few minutes on this; it is not about putting in great detail. With your hand or a rag, lightly brush your drawing away, leaving a soft and quieter version. Now spin the canvas one turn and begin again.

2. Once you have the canvas in a new orientation, you will draw right on top again. This time use some pastels, choosing a few colors that will stand out against your ground painting color. Lay down another loose sketch, trying a different placement of your pot and blooms in your new format. Feel free to go fairly big on the canvas. When you are done, gently wipe off your drawing with your hand or a rag. Spin the canvas another turn.

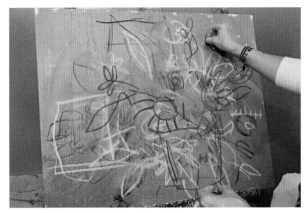

Spin a third time and then draw again.

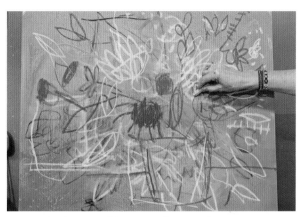

Drawing the third pot of blooms in yellow pastel

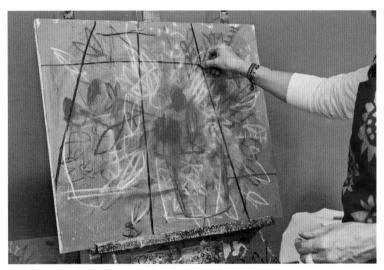

Use charcoal to draw crisscross lines from one edge of the canvas to another.

3. On your third spin, you will repeat what you have done so far. Take two new pastels in two new colors or maybe use the vine charcoal again and one new color. Now you should be feeling loose and getting a good feeling about where your pot might look best. You should have a warmed-up hand that gives you a lyrical line. Enjoy the music in this process and have fun! Now gently wipe out your layered drawings. You will want to see the drawing underneath, but not all that much. Remember, it's only a layer!

4. This step is very important because it helps create shapes that we will use for our next layer. Take your vine charcoal and make six to eight crisscrossed lines from edge to edge on your canvas. Go diagonally from corner to corner, up and down, left to right. When you are done, you will have a great new pattern that will lead you perfectly into Layer Three. Give yourself a hand for staying in the moment and trusting the process. Now go wash your hands; I bet they are a little messy. Bravo—you are getting looser and freer by the moment.

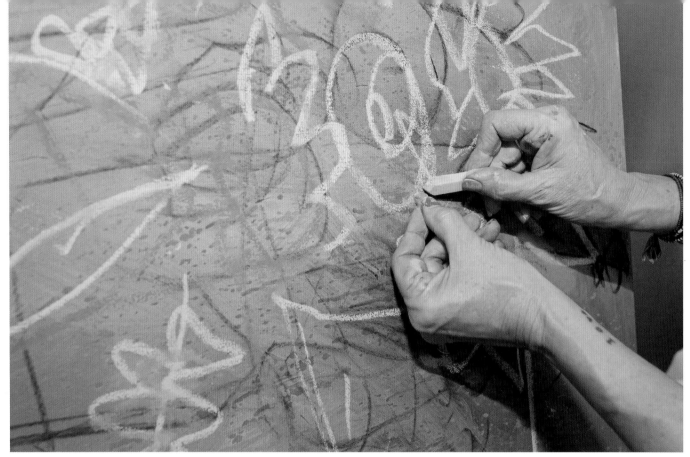

Drawing with both hands creates interesting shapes.

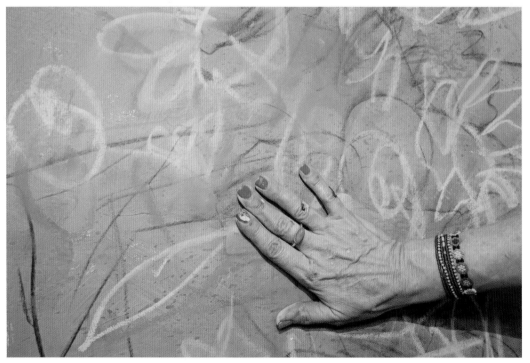

Lightly wiping off the drawing softens the line, allowing you to continue building new layers.

layer two tips

"All creative people want to do the unexpected." —Hedy Lamarr

o Use both hands and two different colored pastels when you are sketching; take every opportunity to try something new.

o Spend time really looking at your flower arrangement and seeing the forms when you draw. Put in darker areas to map where your darks will be.

o Practice varying your line quality.

o Choose some pastels that are opposite in color to play with the vibration.

o Take this opportunity to soak in the idea that nothing is precious because much of it will be covered up.

o Embrace the messiness when working with pastel. No worries—it will all wash off.

o Have on some music that will give your art making buoyancy and energy.

o The more fun you have in the early layers, the more "juice" will come through in your finished painting. Viewers can sense the fun and discovery happening during your artistic process. Those who see your work will feel the joy that went into making them. Win-win!

Dust from pastels can be messy.

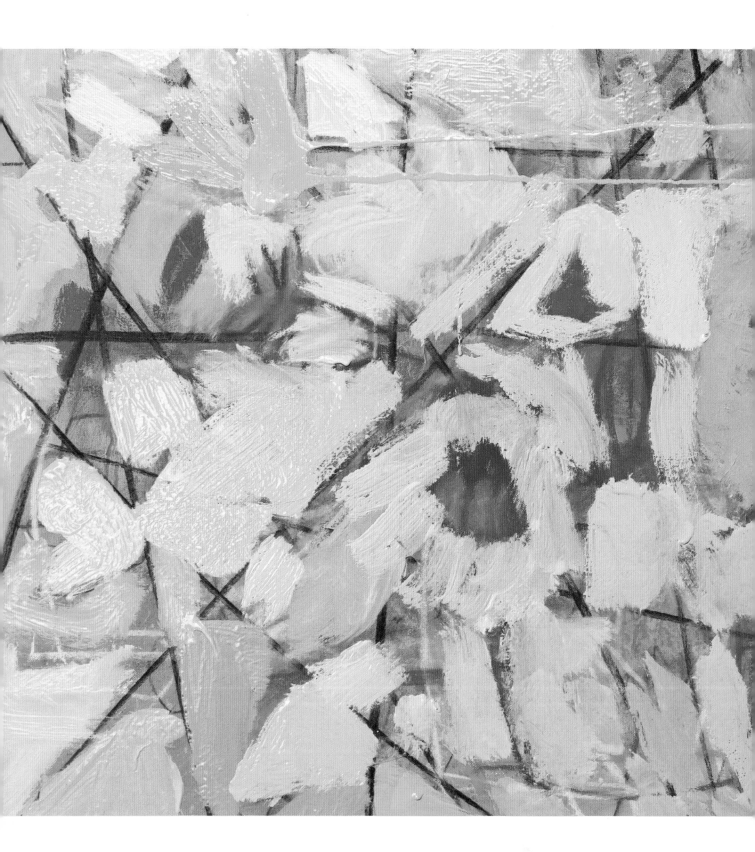

layer three
neutral under painting

It's time to bring back our paints and start building our next layer. The great thing about Layer Three is creating an unexpected pattern of abstraction. There is no pressure as you fill in the organic spaces created by your spin drawing layer. You cannot do this wrong, so have a good time and stay in the moment while painting with warm and cool neutral tones. Enjoy thick and thin paints, using different brush strokes, and adding a few gooey drips. You are setting yourself up for the next layer of vibrant color to pop by putting down these yummy neutral shapes. A wonderful sophistication begins to build as you layer with pattern and color. And as you know, it's only a layer!

big idea

How much can I enjoy being in the moment while I create a layer of abstracted pattern with neutral color?

materials

Acrylic paints, in dulled-down, medium-toned, warm neutrals

Canvas or canvases with spin drawings, complete with crisscrossed lines to the edges (Layer Two)

1-inch (3 cm) brush

Water bucket

Rags

Music suggestion: your favorite upbeat dance music to keep you moving and in the moment

how it works

1. Mix up some mid-toned neutral colors that are in the opposite color of your under painting. If you have used a blue-gray under color, you should reach for dull oranges and warmer neutral colors. The idea is to take any opportunity to let colors vibrate off of each other. A warm orange against a cool blue is exciting for the eye.

2. Have fun filling up the random pattern that your spin drawings created. Try to make slight shifts in your color each time the brush hits the canvas. Choose a limited palette of warm neutrals to play with here. Remember it's only a layer, so you cannot make a mistake. There is no pressure.

3. Be sure to leave room on the edges of each shape that you are filling in to let the under layer show through. Don't "choke" out all of your ground painting color. I like to call this "letting your painting breathe."

4. You may end up filling shapes that turn out looking like some of your flower forms, which is great. You can spin the canvas and have fun with this layer. The more energy on your canvas, the better. This is the perfect jumping off point for our next layer. If you just love what is happening at any point in a layer and decide to keep your canvas as it is, feel free. You don't always have to cover up something wonderful. Please follow what inspires you. I would suggest that you start again with a new canvas from Layer One and bring it up to this point. It is really important to go through the entire layering process from start to finish on at least one canvas.

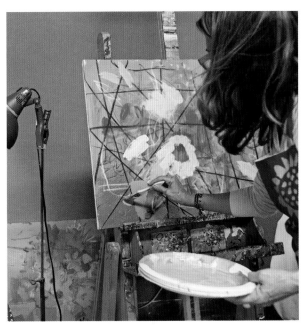

Paint your canvas with a neutral color.

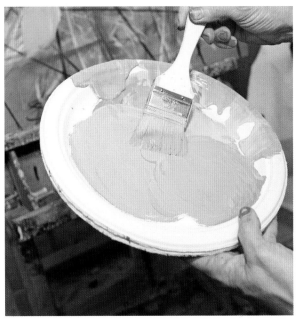

Mix an opposite neutral color on your palette.

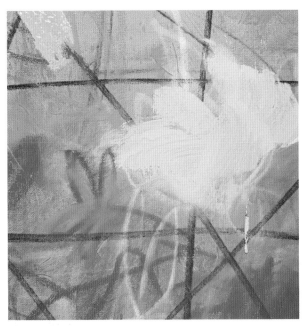

Paint the opposite neutral color in an abstract pattern.

Create drips by holding the brush against the canvas.

Be sure to leave space to let the under painting show.

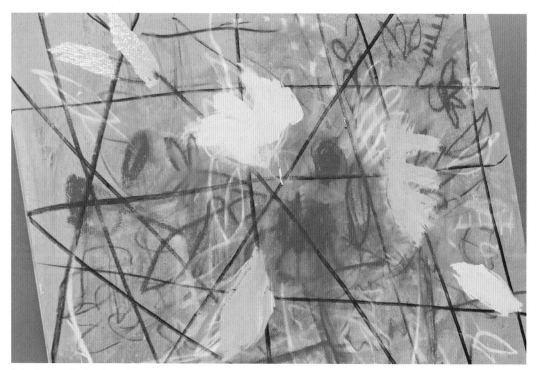

Paint in some leaf and petal shapes.

layer three tips

o Allow some of the under painting to show through by not painting right up to each section. Let your painting breathe.

o Discover new ways to apply your paint, both thick and thin.

o Spin the canvas often as you fill in the sections.

o Choose several small sections and fill them in as one.

o Create different-sized shapes for interest.

o If you find yourself creating a flower shape from your under layer, go for it.

o If one of your Layer Three paintings turns out so great that you want to keep it, hang it up in your studio space for inspiration and to remind you of what you learned in this layer.

o Take any opportunity to play with applying different brush strokes.

o Play with drips and add a spatter or two anytime.

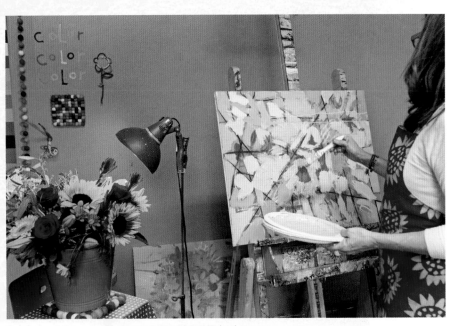

Cover about 80 percent of the canvas with neutral color.

layer four
spin composition

When Layer Three is dry, it is time to look, draw, and decide on the best composition to paint your blooms. Very exciting! Take your vine charcoal, look closely at your flower arrangement with a light source, and begin to sketch the possibilities. Start with a vertical format as you look into your last layer and see if you find a shape that looks like a pot or a bouquet of blooms. Sketch in with charcoal loosely, stand back, and see how it feels. Next you will slightly wipe out the sketch, spin the canvas, and look at the horizontal format. Squint and search for design possibilities in the shapes on the canvas. Do you see a pot shape? You will do this three times, using some colored pastels in the process, until the best option for sketching your "hero" pot of blooms reveals itself. You might be amazed how vases, table tops, and flowers show up during your spin composition.

big idea

How can I find the most interesting composition for my painting?

materials

Canvas or canvases with neutral under paintings (Layer Three)

Vine charcoal

Flower arrangement and light source

Rag

Soft pastels, assorted colors

Music suggestion: perhaps classical, as this is a time for focus and decision making

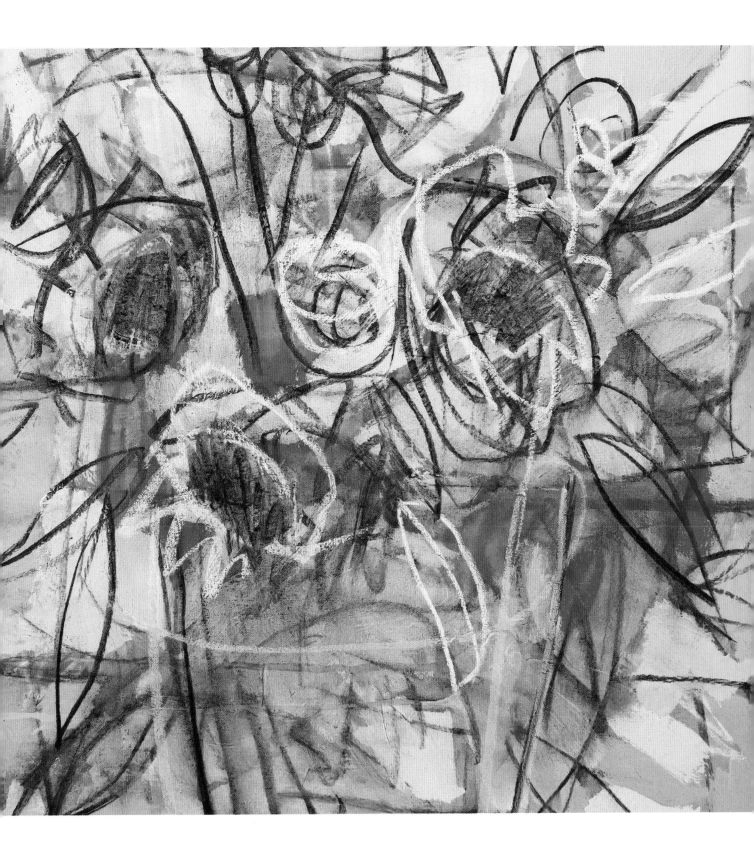

how it works

1. Now you are now searching for the best composition for your painting by trying different possibilities.

2. Take your time and look at the pattern you have created. Make notes in charcoal of possible places to place your pot of blooms as you begin to realize the layout of your painting.

3. Wipe the drawing slightly and spin the canvas. Spin your canvas at least four times, sketching in ideas with charcoal and pastel each time and gently wiping them out.

4. Try to stay away from a composition that is smack in the middle; put your pot slightly to the left or right.

5. The more you rotate the canvas, the more you will get a sense of what is working best. Let your instincts help guide you.

6. Once you have found your favorite design, redraw it with vine charcoal and pastel, as you create a final map for your painting.

7. Finally, add extra colors of pastel as you draw in your blooms, putting in your darkest darks and lightest lights. Loosely draw in your leaves, stems, and table plane.

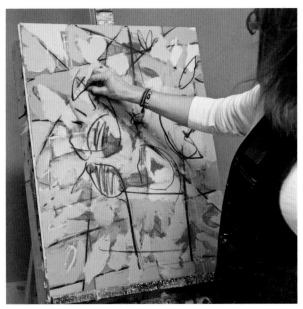

Set up your canvas and draw a vertical composition, looking for a pot shape within the pattern.

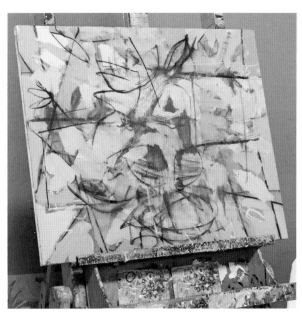

Lightly wipe out and spin the canvas.

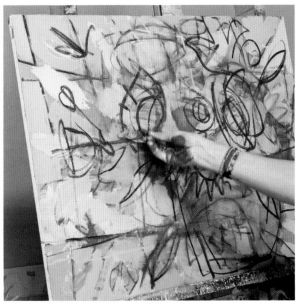

Sketch in a new possible composition.

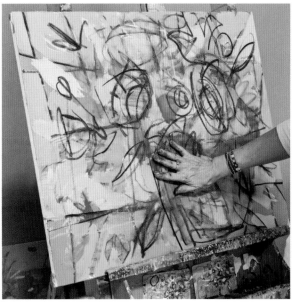

Wipe out again and look for hero composition.

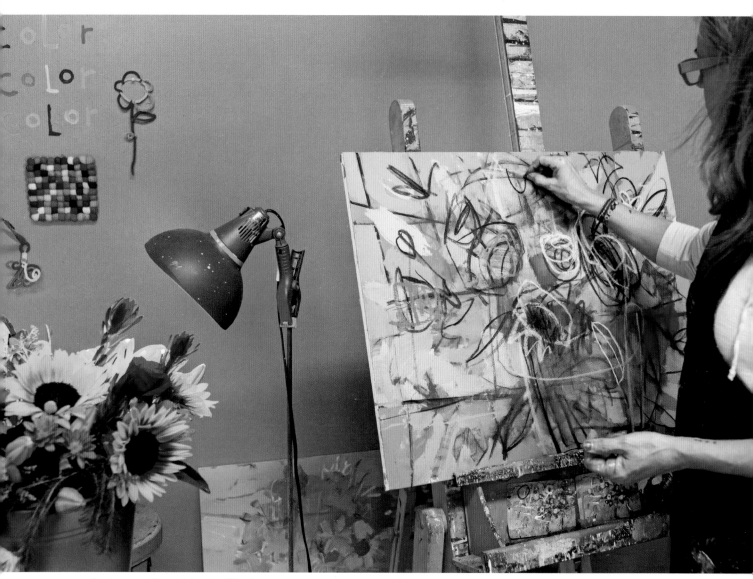

Final composition and draw in with color

layer four tips

"Developing a composition is a creative process involving intuition and thinking more than rules." —Alessandra Bitelli

o Squint your eyes to help simplify your large shapes; you will be able to see your overall design better.

o Walk away from your composition and come back to see it with fresh eyes and from a distance.

o The more loose information that you put down in your spin composition, the better.

o Think of your pot of blooms as your "main event" and the focal point of your painting.

o When drawing in your composition, choose to put a few leaves or blooms all the way to the edge of your canvas. This will help to create interesting negative shapes.

o Make your pot of blooms large enough to fill the canvas. Any liberty that will strengthen your design is allowed, so add an extra leaf or bloom.

o Enjoy the music and your beautiful flowers during this process, and remember, there are many more layers to come, so there are no worries and no mistakes.

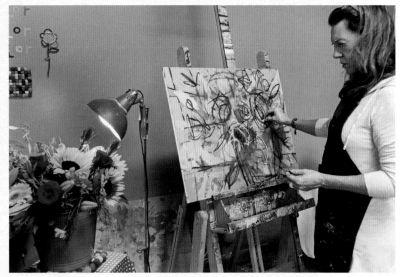

Find the darkest darks and place them in the painting map.

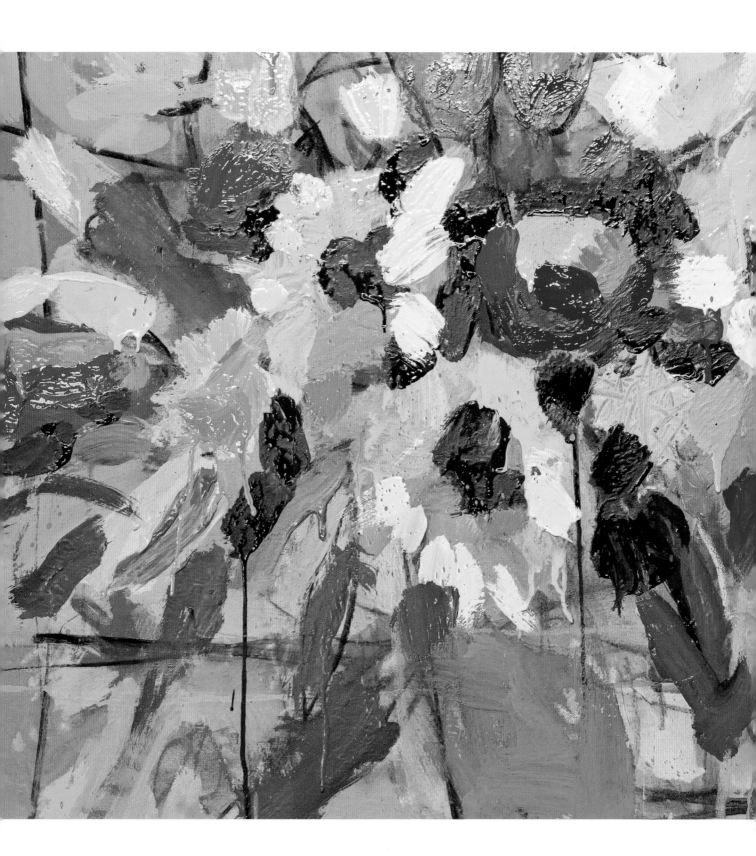

layer five
painting bold blooms

It's time to paint again! Using vibrant colors and big brushes, describe your fresh pot of blooms with loose and free brush strokes. Translate one flower at a time. Use your light source to help you see the light side and the shadow side as you build your forms. Mix colors that will represent the brights and the duller shadows. Add your darkest darks and your lightest lights. Dance with drips and spatters to add energy and personality to your canvas. Move forward with lots of freedom. Turn your music up and try new things as you layer, layer, layer!

big idea

How freely can I translate shapes and forms of flowers onto my canvas?

materials

Canvas or canvases with your spin compositions (Layer Four)

Flower arrangement and light source

Paper plate or palette

Acrylic paints, especially vibrant tones

Brushes

Water bucket

Rags

Drop cloth

Music suggestion: rock music or pop music that makes you energized and want to move!

how it works

1. Start by choosing a few bold blooms that you have sketched in on the canvas. Look deeply at your real flowers and squint so you can identify the light side and the shadow side. Use your paper plate palette to mix a few colors for one bloom, and nicely and loosely lay down some paint! There are more layers to come, so feel free to be a little sloppy and drippy. Why not?

2. Once you have most of your blooms in place, step back, and look at your painting from a distance. Often this could be a nice time for some chocolate or a little break. When you come back with fresh eyes, look for the areas in your flower that have the darkest darks. Squinting will help you see simple shapes and values.

3. Mix up an interesting darkest dark. Try to create a dark with several colors in it without relying too heavily on just black. The richer you make your darks, the more interesting they will be. You might use a deep crimson with a green to create a luscious dark. Put in loose chunks of your dark in the areas that need it; even if it seems random, it will read from a distance.

4. Next mix up your lightest light on a clean paper plate or palette. Use some yellow in with your cream or white paint so there is a very bright feeling in your lights. Put in your brightest brights.

5. You may or may not want to cover up much of your background color just yet. You might leave it as is for your table plane or for your pot. If you do add color to your pot, do it loosely; don't fill it all in . . . let it breathe. Having the under painting show through adds interest and sophistication to your painting.

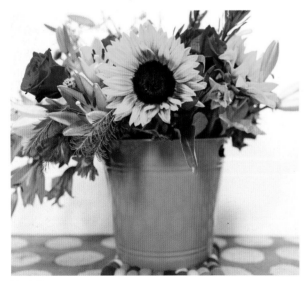

Fresh flowers as muse

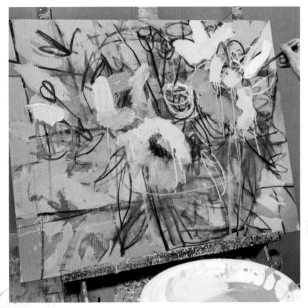

Use your charcoal composition map for bloom placement.

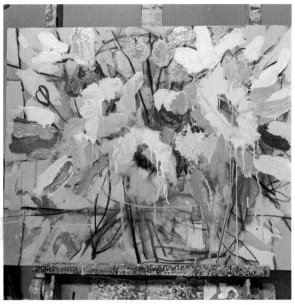

Paint in more flowers.

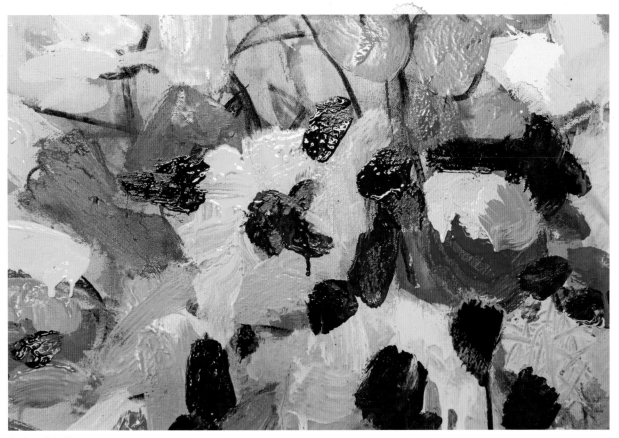

Darks painted in

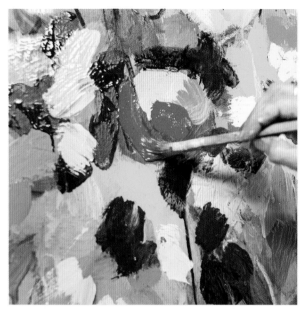

Use bold brush strokes.

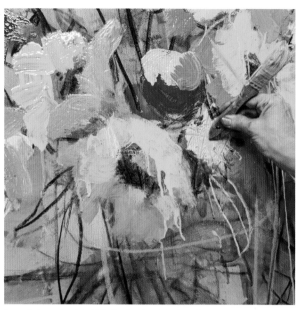

Draw into wet paint with the back of the brush.

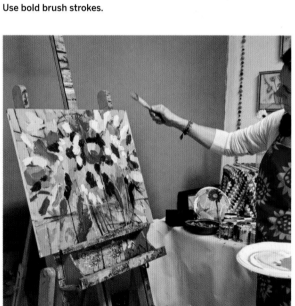

Add spatter for texture and color.

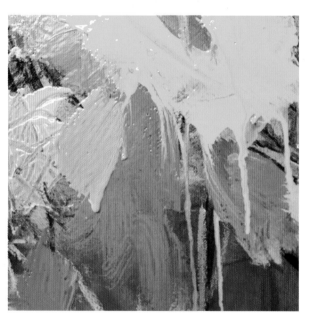

Vary paint quality.

layer five tips

o The larger the brush stroke, the less tight your painting will be.

o Use the back of your brush to draw into wet paint for a great line quality and texture.

o Consider where your light source is and make it apparent in your painting.

o Spattering adds great energy and extra color; use it often.

o Rely on darks and lights to create your flower forms.

o Take liberties with leaf and stem shapes, putting them where you need them.

o Notice interesting options for your table plane.

o Your instincts are golden: Keep listening in for nudges on what to do next.

o If you ever feel stuck, take a break, have a snack, or enjoy a short walk.

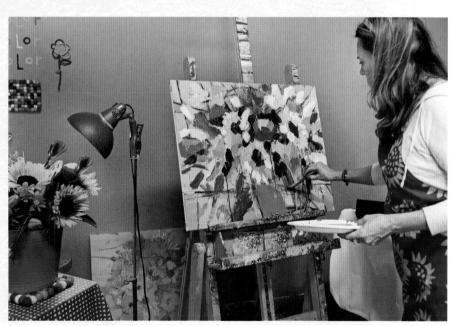

Add pot color and find the table plane.

layer six
cutting in the background color

First, pat yourself on the back for creating such luscious layers of color and form. Bravo! Now we are going to play with the background, which will help define the bigger shape of our entire pot of blooms. In Layer Six, you will create new visuals by painting around the edges of your leaves and blooms. Be sure to leave a little extra space around your forms to let the beautiful under layers show through. New shapes will be born and your composition and overall design will come into focus. The table plane will start to emerge, as will your pot shape. If your background layer is already working for you, you don't need to "cut in" if you don't think you need it. As always, follow your brilliant instincts—this is *your* painting!

big idea

How can I best edit and organize all the energy on the canvas?

materials

Acrylic paints

1- or 2-inch (3 or 5 cm) brush

Canvas or canvases with bold bloom painting
(Layer Five)

Vine charcoal

Water bucket

Rags

Music suggestion: indie rock or singer-songwriter,
a coffee house vibe

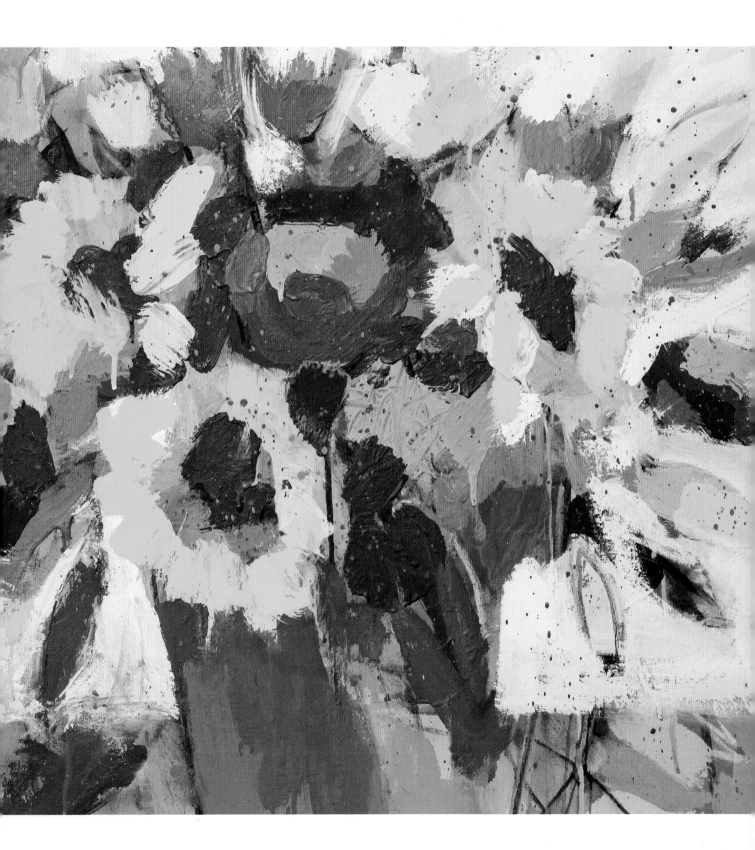

how it works

1. Mix up a nice light or dark color that appeals to you; either one can be used to help define the foreground from the background.

2. With your 1-inch brush and your thinned down background color, begin to loosely brush around your shapes, making sure to leave some extra space so that your under painting shows through. This is also a chance to let your painting breathe.

3. Work around your entire pot of blooms, carving in new shapes, adding new leaf shapes, and creating interesting edges with your brush.

4. Stand back and squint, letting the entire painting reveal which is the background and which is the foreground. Tweak your shapes with additional carving in.

5. Make a note of where you will want your table plane and gently draw it in with charcoal. You might move the line a few times and play with the shape of your vase or pot until it feels right.

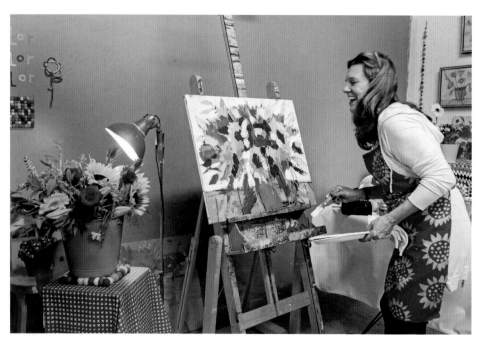

Music up, ready for Layer Six

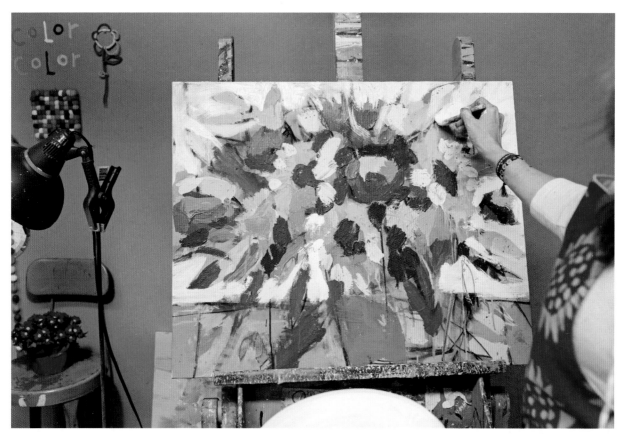

Cut with light paint around the blooms.

Add new petal and leaf shapes.

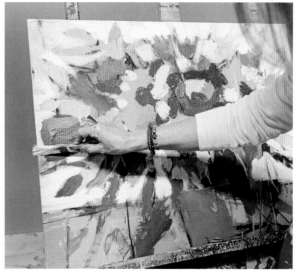

Create a large shape with paint from the edge of the canvas.

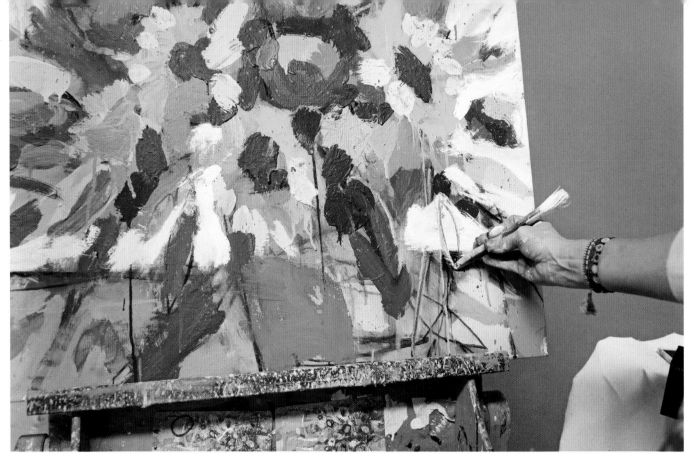

Carve leaf shapes in the wet paint.

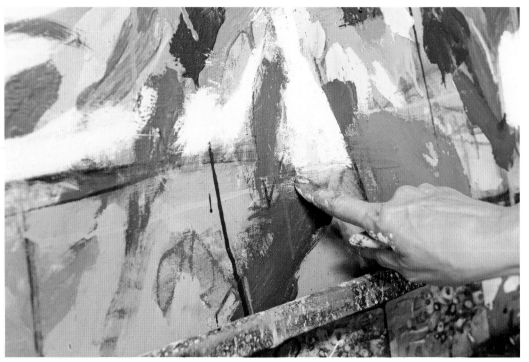

Find your table plane.

layer six tips

o Take a photo of your painting at this and many stages as you work. Looking at the photos will help you see your entire design.

o Use the back of your brush if you want to pull some of the paint off or make some interesting textures.

o Work in thinner layers of your background color as you build it up to the consistency that you like.

o Leave your table plane as is if you like the way it works with the pattern of your last layer.

o Let some of your under painting show by leaving a little extra room around your shapes.

o Try cutting in on at least one area even if you like how your background looks the way it is. Take the opportunity to discover new preferences.

o Add a little spatter on your blooms on top of the new background color.

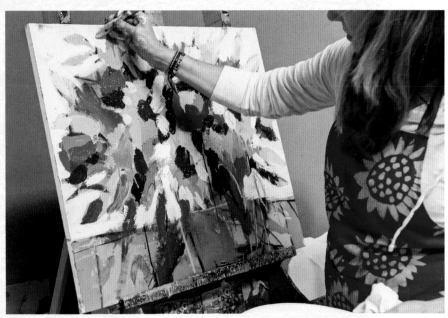

Draw in wet paint with the back of the brush.

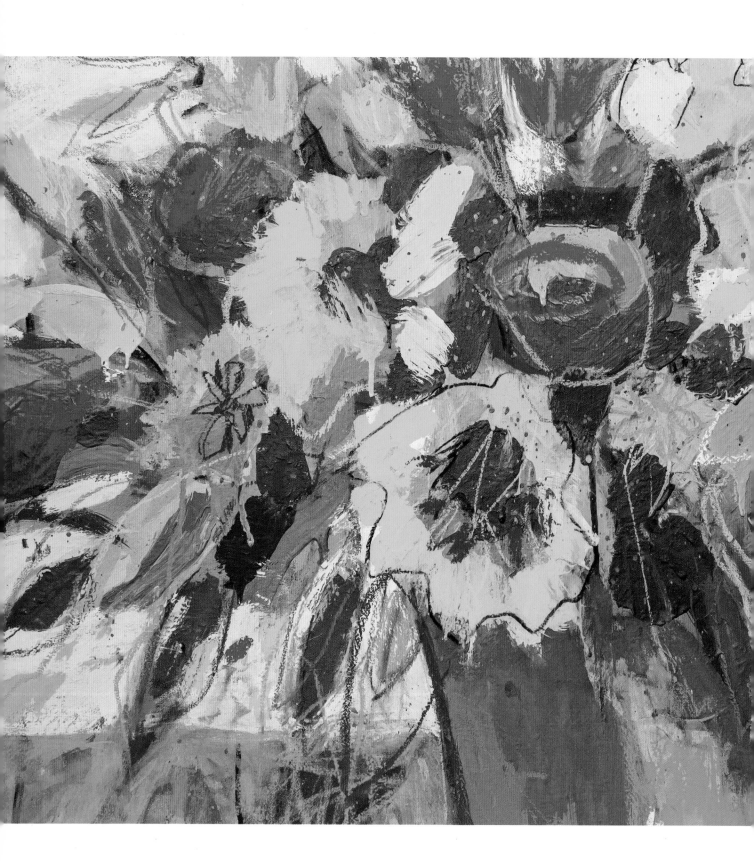

layer seven
expressive and energized drawing

big idea

How can I most enjoy adding a thick and thin line to energize my painting?

Beautiful job with Layer Six, cutting in with paint to create your background shape. Now it is time for Layer Seven, your expressive and energetic drawing. This layer of fresh and free line work brings so much to your painting. There is a special quality that drawing adds: It shows the "hand of the artist," which is not only appealing to the eye but is also full of life. This expressive drawing layer gives you an opportunity to slightly overlap and restate your shapes. You will use contrasting, vibrating color on color and you will add new marks. It will bring loads of interesting variety to the surface of your blooms.

This is a good time to look back at your warmup fifteen-, thirty-, and sixty-second timed drawings for inspiration. You want to put the same loose, childlike quality into this layer. Draw freely. Use both hands. Make staccato marks. Create new shapes with thin and thick line. Pop color on top of color. Dance and make yourself smile!

materials

Canvas or canvases with cut-in background color (Layer Six)

Flower arrangement and light source

Chalk/soft pastels, assortment of colors (use oil pastels or water-soluble crayons if you prefer not to use spray sealer)

Pencil

Music suggestion: funky or jazzy beat, something with a different rhythm

how it works

1. Layer Seven will add zest and joy to your painting with freeform, flowing line work. Start by drawing over your leaf shapes with an overlapping line or pastel in a bright or opposite color. Use both hands and be free!

2. Go inside some shapes and make marks that help describe some part of your blooms. Create patterns, dots, and dashes. The more these colors can vibrate off of each other, the better. Explore and play! You are adding energy and sparks to your painting.

3. Restate your line and shapes by drawing in highlights on top of your blooms. Scribble and move your hands quickly in some areas. Look at your blooms for inspiration. Create entirely new shapes with just line against your background color.

4. Feel the energy that you can bring to the final layers of your painting with your line work; move in and out of different shapes with abandon. Be free! Think of this layer as adding the special garnish to a dish or a flourish on top of a beautifully wrapped package.

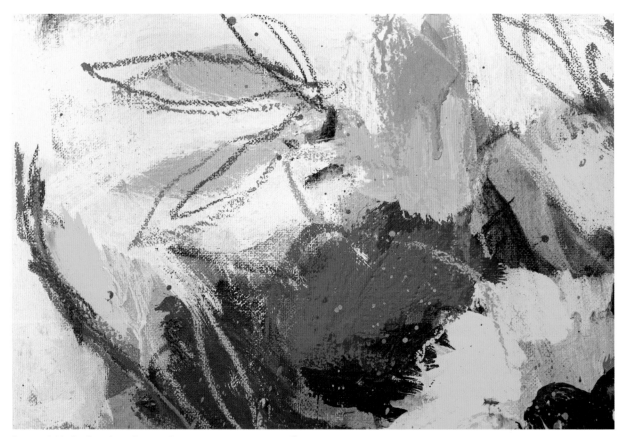

Draw outside the lines to make new shapes.

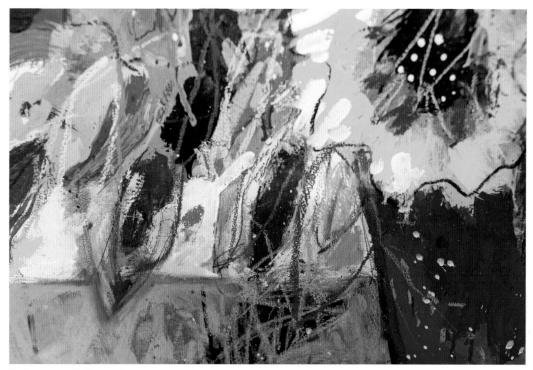

Explore energetic line work.

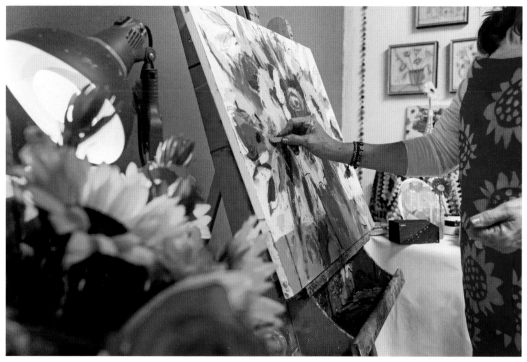

Use different colored pastels and playful line.

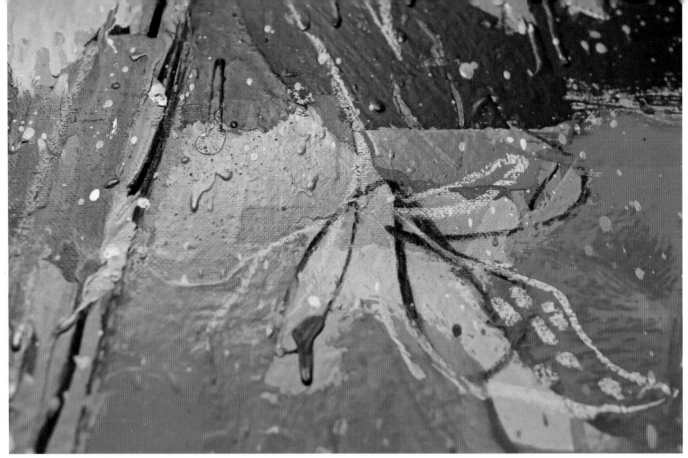

Make marks with dashes and dots for extra visual energy.

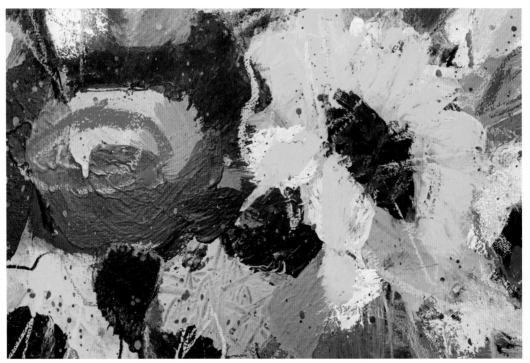

Enhance a flower's vibrancy by drawing with a slightly different color.

layer seven tips

"Art is a language, an instrument of knowledge, an instrument of communication." —Jean Dubuffet

o Separate your pastels into two bowls, one with warm colors and one with cool blues and greens, so it's easy to grab them in the moment.

o Take a childlike approach with your drawing; go outside the lines.

o Use different colors of line on top of your painting shapes.

o A tender pencil line adds a wonderful poetic quality and will pull your view in.

o Create a combination of thick and thin lyrical lines by spinning your pastel or pencil as you move it across the canvas.

o Make marks by adding dashes and dots in spaces that need a little extra energy.

o Make many marks that create a leaf shape that isn't in your painting yet.

o Restate your lines more than once.

o Take liberties and artistic license; have fun.

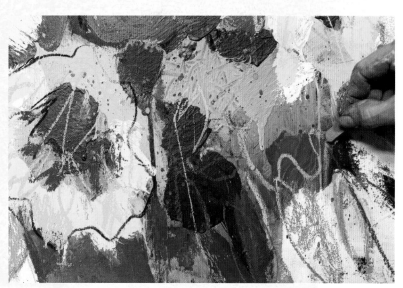

Vibrate color.

layer eight
finishing touches and highlights

How do you know when your painting is done?

Look closely over your entire painting to see what it needs. Is there a spot where a tender pencil line could pull the eye in? Could it use a tad of dark? A bright highlight? This is the time to place your final touches, poetic marks, and lyrical lines. Outlining and smudging your edges with pencil will give your shapes a beautiful halo effect. You will start to see things come forward and push back. Some things will need to be soft and others crisp.

Make sure you have a "main event," most likely your vibrant blooms, and let your background and table act in a supporting role: not competing, but interesting and compelling. You might wish to do one last "cut in" of color to further define your background shape. Your instincts will tell you what to do. Have all-over vibrancy if that feels good.

As you stand back and look, you will see areas that need tiny tweaks. Some require just a touch of pencil or a colored line. Maybe add tiny dots of bright color in the center of your blooms. Something will click when your painting is done and you will be ready to add your signature. Such an exciting moment! Bravo! All of your bravery, brilliance, and willingness are beautifully arranged in your final painting. It's time to celebrate!

big idea

How can I take my painting all the way through to the final finish?

materials

Canvas or canvases with all previous layers (Layer Seven)

Flower arrangement and light source

Brushes, including small round brush for details and signing your painting

Acrylic paints

Soft pastels, oil pastels, or both

Soft lead pencil or graphite stick

Water bucket

Spray varnish

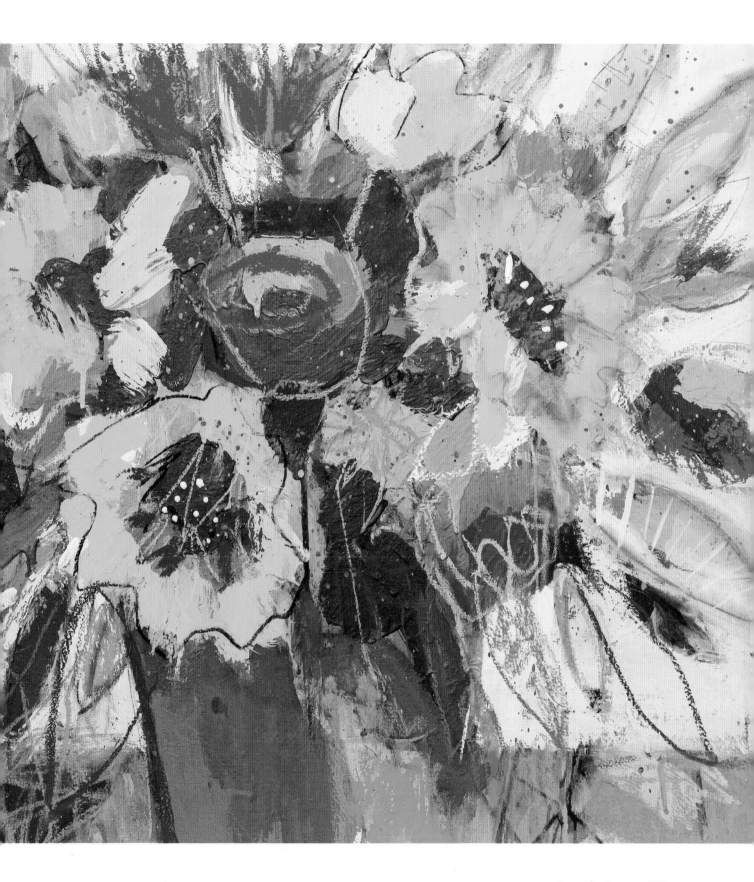

how it works

1. Now comes the joy of adding the final tweaks and touches. Start with a small round brush and bright, light paint to add extra highlights on some of your blooms. Look at certain edges of petals in the light and make a thin line to create a bright spot. You can also add some lines and patterns in a few leaves or petals just for fun and interest.

2. Take the back of your round brush or your pencil tip and dip it in white paint and add small dots in the middle of some blooms or along the edges. When you back up, you will be amazed at how these little hot spots can delight the eye. You might try using a bright color or two if you see a spot that needs it.

3. Use your soft lead pencil or graphite stick to make outlines that go along certain edges or slightly overlap some shapes. With your fingers, give the pencil or graphite line a little smudge. This will give your shape a darker "halo" effect that is really effective in pushing some shapes forward and some back. It is a great finishing touch to add along several of your outside edges.

4. When your painting is done, you'll know it, so look for the perfect place to sign your work! This important finishing touch feels wonderful. You can choose a color that will complement your painting or one that will be a little less obvious. A small, thin brush will work, or you might want to try a rigger brush, which has long, thin bristles that make it easy to pull the letters in paint.

5. Give your final painting several sprays of varnish to seal in the pastel and keep it from smudging.

Please take a moment to congratulate yourself on a great painting journey! I hope you enjoyed the layering process and felt it freed you up in a new way and allowed for fun, in-the-moment discoveries. Painting is fun! Bold blooms are exciting to make and to see. I hope you will share your work with friends, family, and collectors.

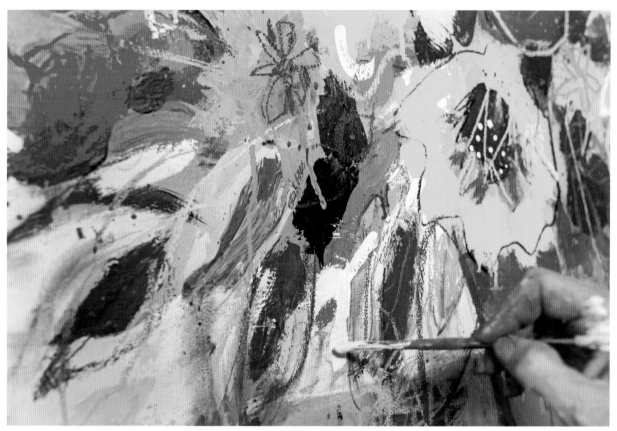

Use a small brush and bright color for highlights.

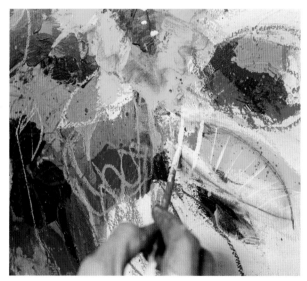

Add additional lines and marks with paint.

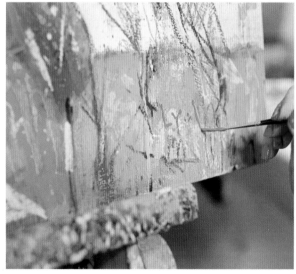

Sign your painting with a small brush.

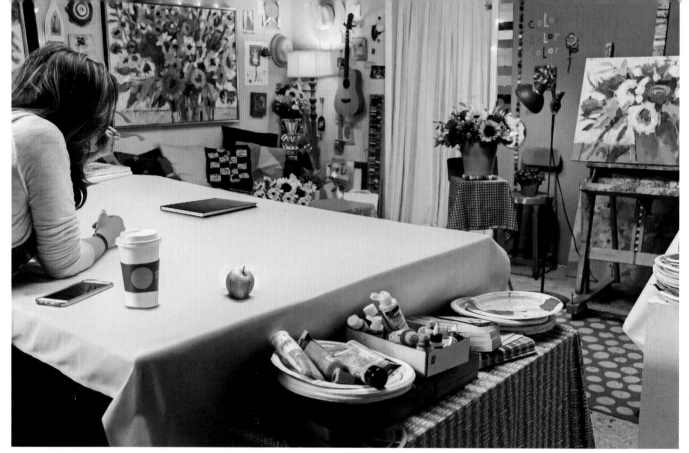

Get perspective by standing back to look at your work from a distance.

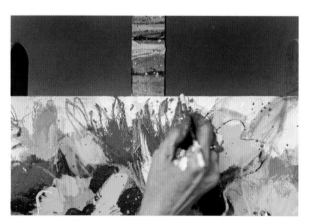

You can change shapes with a small brush.

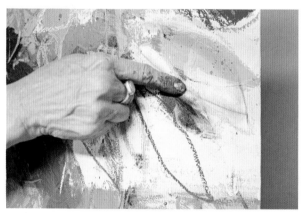

Smudging the pencil line adds a halo effect.

layer eight tips

o Standing across the room will let you see the entire painting.

o Squint your eyes and look for harmony and flow on the entire canvas.

o Change some outside shapes with a small brush and light paint.

o Notice places that could use a little touch of extra highlights or mark making.

o Outline the edges of some leaves and blooms with a soft lead pencil and smudge with your fingers to create a halo effect.

o Consider a balance between poetic touches and bold vibrancy.

o When spraying your final coats of varnish, do it in a well-ventilated area or outside.

o Make notes about all the things you enjoyed most about the painting process so you can use them in your next pieces.

o Pat yourself on the back for doing a great job. BRAVO!

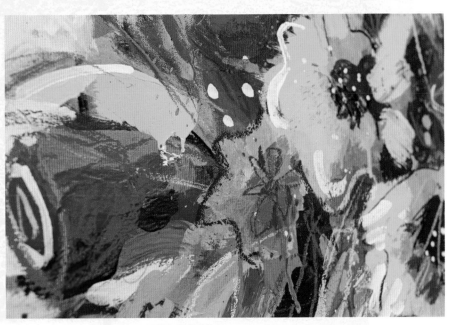

Create compelling details.

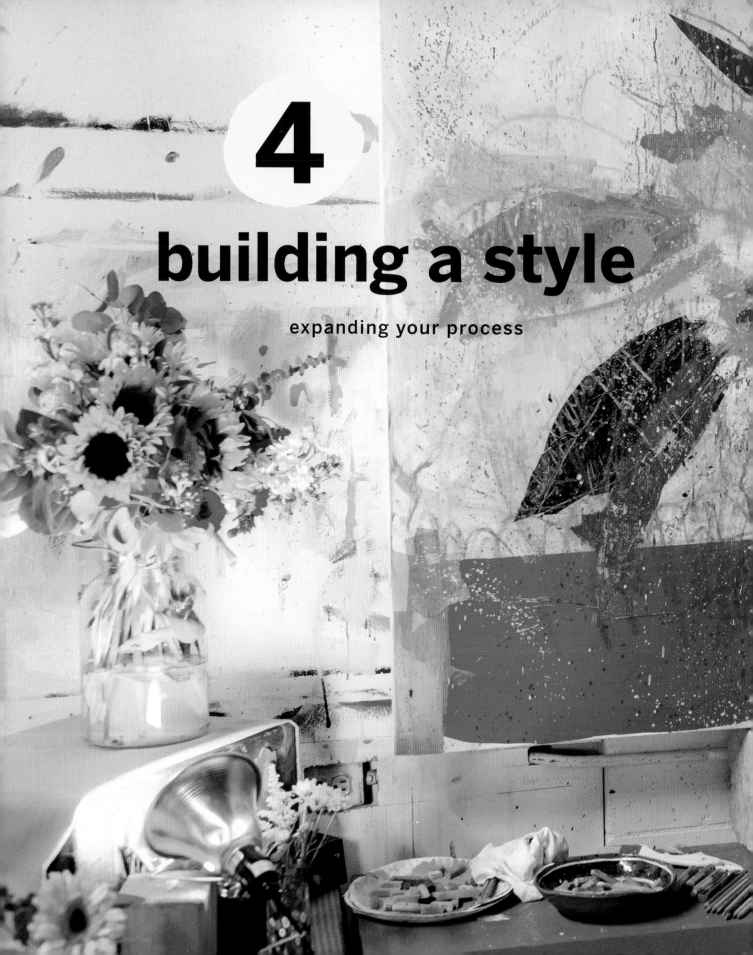

4
building a style

expanding your process

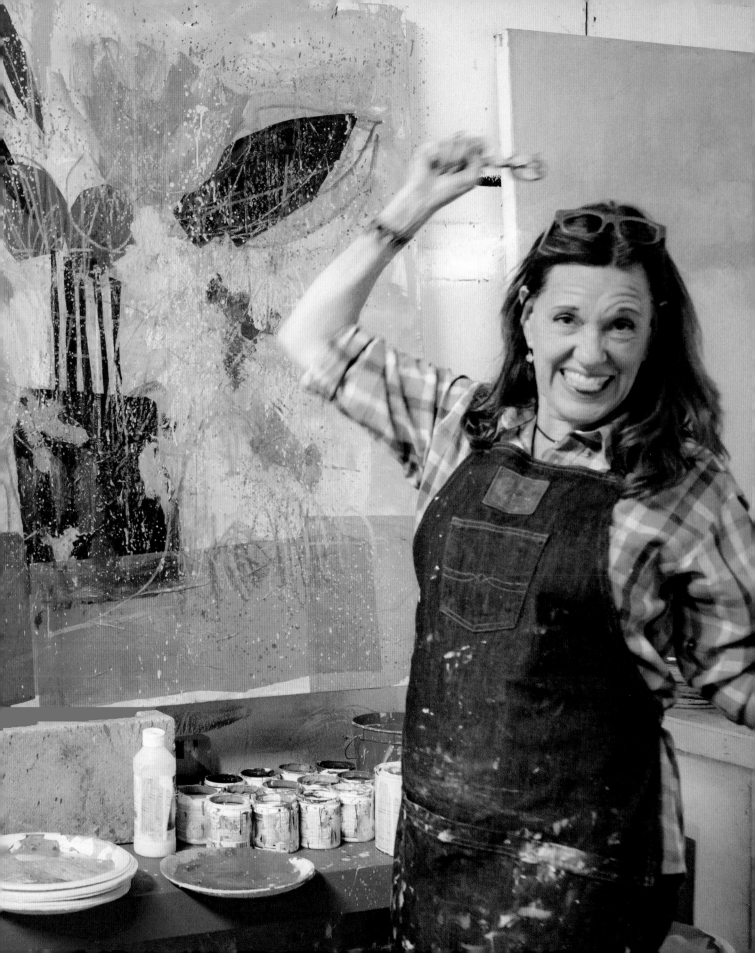

IT WANTS
TO BE MADE
AND
IT WANTS TO BE
MADE BY
ME

exploring your voice

"Creativity is a crushing chore and a glorious mystery. The work wants to be made, and it wants to be made through you." —Elizabeth Gilbert

Your voice is already there. Perfectly you. Sometimes it's quiet. Sometimes quite noisy. I love the above quote by Elizabeth Gilbert. The work wants to be made and it wants to be made through you. One day as I caught my breath after a crazy day of painting, I scratched a version of Liz's beautiful quote on a paper plate. I hope she doesn't mind. It was as if my brush was at the tail end of a tornado, and I was just hanging on, being bossed and tossed around. It was pouring through me faster than I could keep up. When I finally took a breath, I grabbed the charcoal and wrote down her quote as quick as I could remember it. I said it out loud over and over . . . That painting had a mind of its own; it wanted to be made and I am just lucky I was here and ready! What a wild ride! I was just the gal holding the paint brush.

Quiet time to listen in

So many wonderful things inside of you want to be created. Born. They want to show themselves to YOU and be made through you. Prime the pump as often as you can. Move your hands. Make notes in your sketchbook. Do some Blue Skying, and dream big! All those little preferences that you are gathering every single day are what make up your voice. It is so exciting. What a journey you are on. I wish you every creative joy possible. Every funny, odd mistake and every tiny victory. Exploring what makes you YOU is the thing that needs to be shared more than anything else. It's what we all need so see. Authentic and perfectly imperfect. The best!

painting bigger, painting bolder

"Hi Lynn, Finally I have finished my first BIG and BOLD. It really was a labor of love and your wonderful lessons carried me to the end with big smiles on my face!! I have never attempted anything this big before and now I can't wait to start another. Thank you so much for helping me through my fear of the BIG blank canvas!!"
—Big Bold Bloom Wild Painting student, Sharon

Now that you understand the freedom of working in layers and playing with line shape, color, and form as you created your previous bold blooms, why not take it to the next level? You are ready to apply the same process but start with a larger canvas. Yep! Take note of the preferences you have gathered from trying all the layers and put them into one giant painting. Did you love the tissue paper collage? Then use it again, only much larger. Which format felt best to you: vertical, square, or horizontal? Were drips your favorite thing or did they make you nervous? Do whatever you liked most and dive in. Play with everything that you enjoyed most and go big! I actually think it's easier to go big than it is to go small; there is more room to move. Unleash all of your energy and play! As you know, it's only a layer. Jump in!

My favorite teacher, David Passalacqua, whom I have already mentioned, said to our class one day something along the lines of "If you want to paint, you are going to make at least 100 bad paintings, so you better get started." Such helpful advice! Just understanding that it isn't supposed to look great when you are learning or trying something new was a fantastic revelation. It's not about the perfection of any one painting, but being in the game and watching your growth that is exciting. Going bigger is a great way to keep on painting and learning.

Try a canvas 36 x 48 inches (91 x 122 cm) or larger, fully aware that you can relax, knowing that everything is about discovery. Stay in the moment. Let each layer lead you to the next. Rely on your instincts, take breaks when you need to, and just see what happens. Splash on some of that favorite ground color and let it rip! Think bigger brushes, more paint, louder music, more spatter, crazier dance moves, more fun! Go for it.

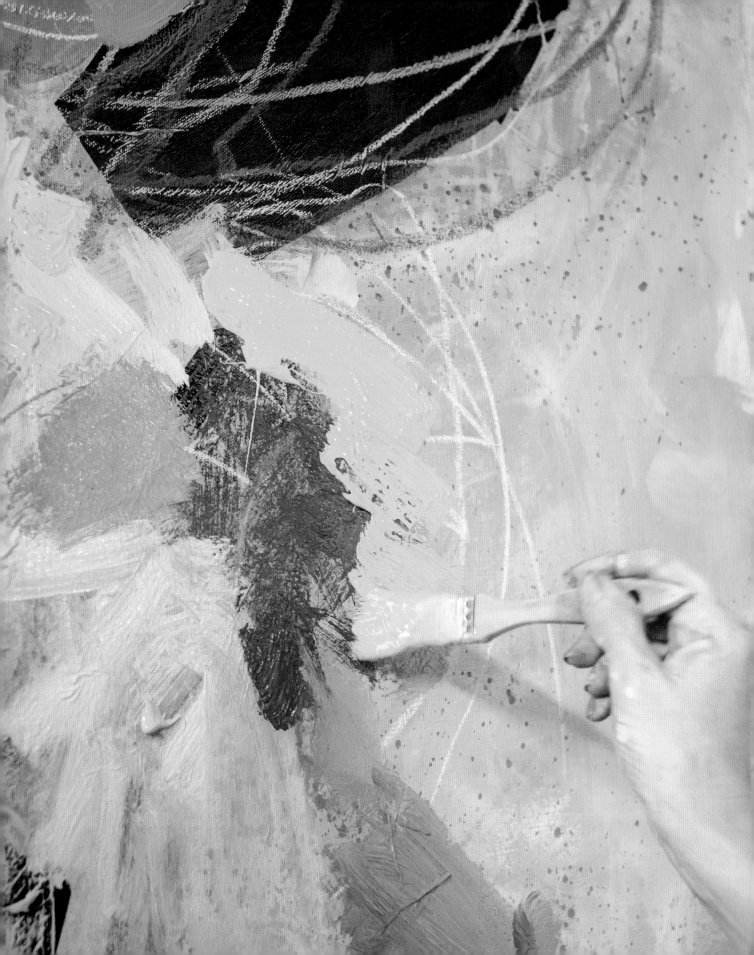

Use a soft brayer to spread paint.

Adding large pieces of tissue paper collage

Rings made with plastic cups

new tools, new layers

As you continue to paint and explore bold bloom paintings, you might want to add a few new twists. I know this sounds simple, but it really works: Use much bigger brushes and your work will have even more of a free feeling! You can cover more ground, make bigger drips, and spatter big time with a larger brush. I dance and sling paint with both hands and two brushes—why not, especially in the early layers? You have to cover a lot of territory with your color anyway! Try it: Ask yourself, "How much fun can I have spreading color and energy?" See how it feels to you. Those large brush strokes and energetic movements pull people in; they can sense there was fun happening in the making of your work.

Another really fantastic tool, and my new favorite, is a soft rubber brayer. A discovery I stumbled on that I want to share with you is to run your brayer through wet (but not super wet) paint and let it track and drag color across your canvas. The brayer brings an amazing new softness to things and adds a poetic "visual noise" to your paintings. Not only does it track flecks of color on top of other colors, but it also adds loads of texture. You will create a poetic quality to the surface of your painting that isn't easy to figure out. A bit of a mystery in any painting is a great thing!

Odd things that you find around the house can make great painting tools. Since our goal is to spend more time in play mode, grab a few items from around the studio and drag them through paint. Have an old potato masher that you don't use anymore? The top or bottom of a plastic cup?

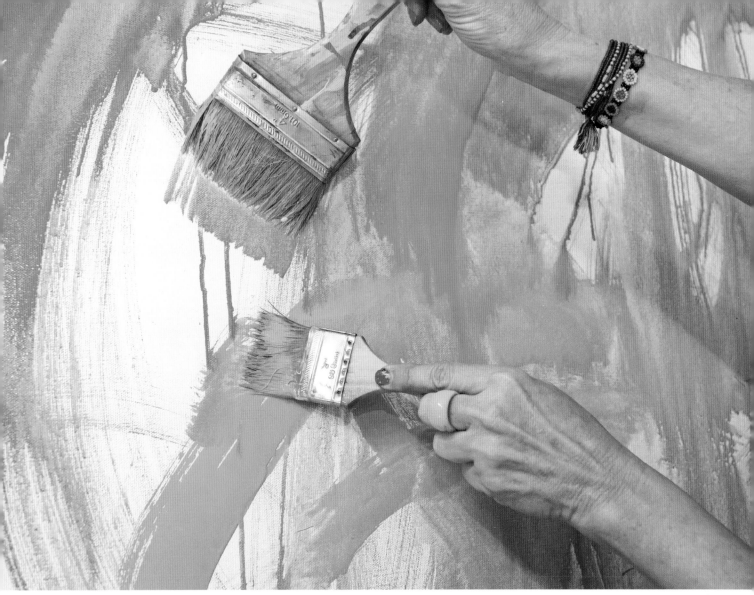

The joy of bigger brushes

Cups make wonderful ring shapes; layer them up and surprise yourself!
One of my all-time favorites is a tracing wheel sewing tool that I refer to
as the "dot dot dot." When you run the dot dot dot through paint and then
roll it on your canvas, it leaves a lovely dotted line that adds a touch of
poetry to the mix.

Add paper collage to your big, bold blooms. First make a seed draw-
ing or small map for your large painting. Draw in the darkest darks. Use
this small map to cut out bold shapes from tissue paper or found paper
and collage them down to build the structure of your painting. Tissue
paper will add great color, shapes, and textures.

one simple sunflower

"There are always flowers for those who want to see them."
—Henri Matisse

You can paint a sunflower with just three colors. It can be very helpful to think of basic flower forms like this: a light side, a shadow side, and a dark side. Practice breaking everything down into simple shapes. Your light source will help you see value, which will inform your color choices.

how it works

Start by toning your gessoed canvas with medium blue-gray. Next mix up a bright, light yellow for your light side, a middle-range darker yellow for your shadow side, and a dark for the center of your sunnie. Look for your brightest bright and put it in. Next, decide where your shadow side is and finally put in your darkest dark. Work fast, and don't worry if it looks like a flower; your goal is to describe a form. When you stand back from your canvas, you will be able to see a sunflower. You can build on top with more nuance, line work, and brush work later, but getting the basic shorthand of shapes will keep you moving quickly and in the moment. Feel free to practice the three-color approach on some of your other favorite flowers.

tips

- Practice painting one single flower at a time.

- Sketch with charcoal a simple map of your sunflower form.

- Squint your eyes and look for a long time before you paint.

- When you are ready and have the form in your mind, paint quickly.

- Play with thick and thin paint.

- Practice a variety of brush strokes.

- Drips happen. Go with it.

- Paint several flowers from different angles to see the way the form changes.

materials

14 x 14 inch (36 x 36 cm) or larger gessoed canvas

medium blue-gray toner

Single sunflower

Light source

Acrylic paints

1-inch (3 cm) brush

Water bucket

Paper plates

Rags

Music suggestion: Dance music, upbeat and lively!

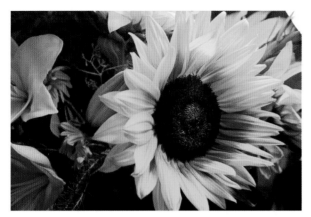

A fresh sunflower

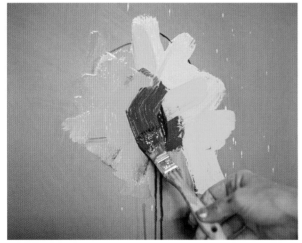

Paint one sunflower.

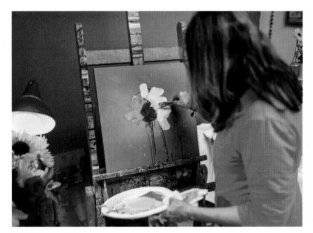

Add darks and drips.

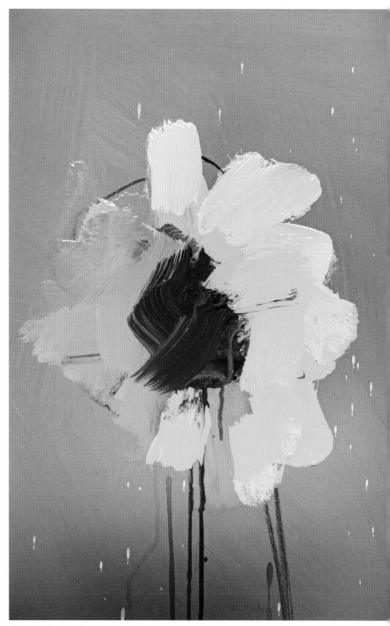

Three-color sunflower

behind the scenes during a painting of big, bold blooms

"Dancing is the last word in life. In dancing one draws nearer to oneself."
—Jean Dubuffet

I have often thought that dancing and painting have a lot in common. They are both fully alive, in the moment, and keep moving and changing shape. When you look at a painting, you don't get to see all of the steps that brought the artist to the final finish. So much gets covered up, many changes are made, and the painting constantly morphs into something new. If you have taken an in-person art workshop and watched your teacher do a painting demonstration, you will have noticed how many different incarnations the painting goes through. Creating a painting is a wild ride, moved forward by a million tiny decisions, actions, and acts of bravery. With that spirit in mind, we documented the making of a large painting from start to finish in my studio. Here are some fun facts and observations I made as the painting progressed.

an overview of the steps and layers

1. Super energetic, messy, orange, drippy ground painting

2. Spattering

3. Dancing

4. Tissue paper collage

5. More spattering

6. Singing

7. Drawing in charcoal and pastel

8. Acrylic paint slinging

9. Using the brayer

10. Laughing

11. More spattering

12. Chocolate

13. More drawing

14. More painting

15. More brayer-ing

16. Cutting in with outside color

17. Expressive drawing

18. Louder music

19. Taking stock from across the room

20. Finishing touches

materials

48 x 60 inch (122 x 152 cm) gessoed canvas

Fresh flowers

Light source

Sketchbook with some seed drawings for inspiration

Acrylic paints

Tissue paper

Gloss medium or thinned gel medium

1-, 2-, and 3-inch (3, 5, and 7.6 cm) brushes

#10 long-handled round brush

Water bucket

Rags

Vine charcoal

Assorted chalk pastels

Spray varnish

Loud dance music

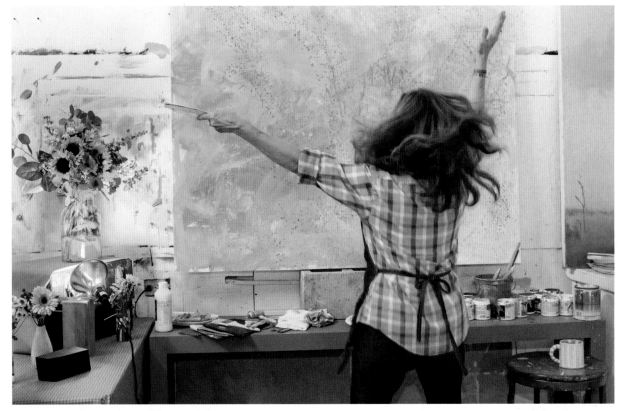

Sometimes you have to dance while you paint!

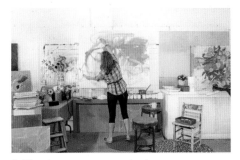

Putting down orange ground color

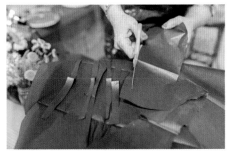

Cutting out black tissue paper shapes

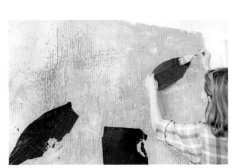

Collaging black tissue leaf shapes onto canvas

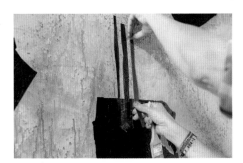

Collaging on black strips for stems

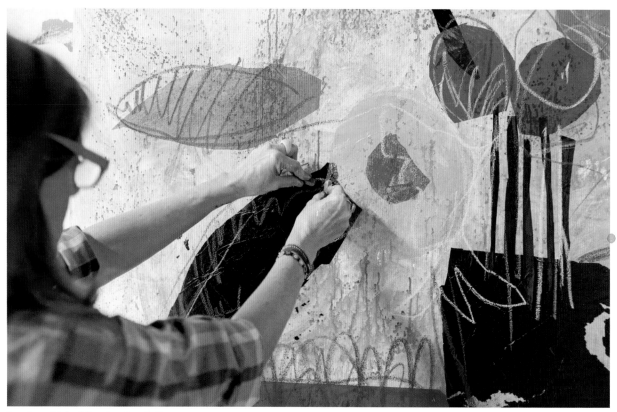

Drawing with both hands using chalk pastel

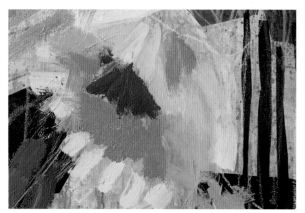

Painting yellow and pink flowers

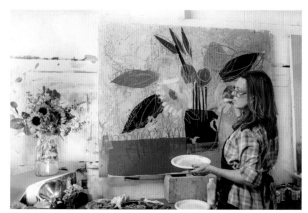

Painting a giant sunflower

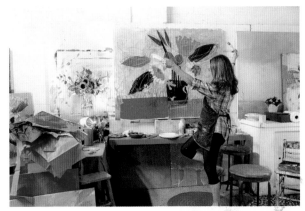
The joy of painting to music!

Have you ever found yourself smiling and singing when you were engaged in something that felt like pure and playful fun? What a wonderful place to be. I like my painting time to feel like a wild, curious romp with art supplies. I think very little about the finished painting and more about moving and trusting the process. Just reacting to the music and what is happening on the canvas. I have read that the simple act of being in motion lifts your mood. When you work bigger, you will be making bigger movements and more of them. Just like a dance!

"It is a happy talent to know how to play."
—Ralph Waldo Emerson

my list of "how many"

Times I turned the canvas: 8 to 10

Minutes sitting or standing across the room just looking at the painting: 267 or so

Times left I the room, then snuck up on the painting to see it with fresh eyes: 15 plus

Photographs taken during the process: 150 or more

Crazy surprises that happened in the process: so many I lost count, one every few minutes

Times I tripped as I was backing up to see the entire painting: 4 to 5

Bites of chocolate: 23.
Okay, maybe only 20; is that bad?

Giant laughs: several plus some

Dorky dance moves: sadly, a million

Songs listened to: 200 plus

Paint spatters on canvas: at least 300

Pastel and vine charcoal marks made: 400-ish

Coats of spray varnish used to seal the dusty pastel: 7

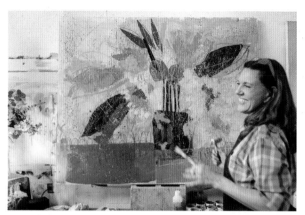
Enjoying the process of spattering and creating texture

I think the most satisfying paintings to create are the ones where we learn something new. There is a special charge that people seem to feel when they approach a work of art that is authentic and was heartfelt in the making. In my experience, the best way to allow that to happen is to let go. Freedom feels good. If you were to have a superpower when it comes to painting, it should be that you didn't give a hoot about what anyone thought. Ask yourself: How much fun can I have? Go for it.

more "how manys"

Times I squinted to see the composition: 70 plus

Times I spattered the painting when I was figuring out what to do next: 10, at least

Different colors mixed in the process: 200 to 300

Times I changed the water in my water bucket: 10

Rags used: 5

Different colors of pastel used: 35-ish

Spatters of paint I got on my shoes: oodles

Times I sang loudly and out of key: 4 hours' worth, at least

Attempts to fit my finished painting in the van to take to a framer: 3 (we had to unload some stuff)

Hours of fun I had: countless!

"Almost all creativity involves purposeful play."
—Abraham Maslow

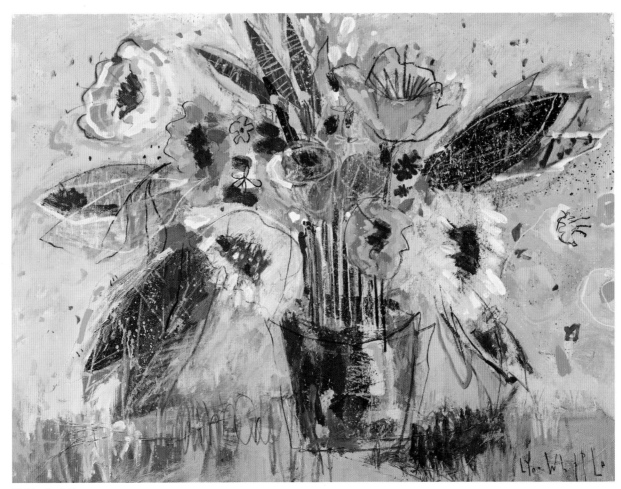

Finished painting

Moving paint across the canvas with the brayer

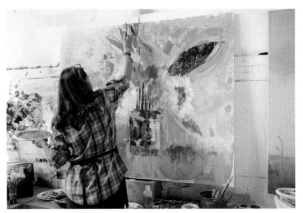

Using orange paint to cut in background color

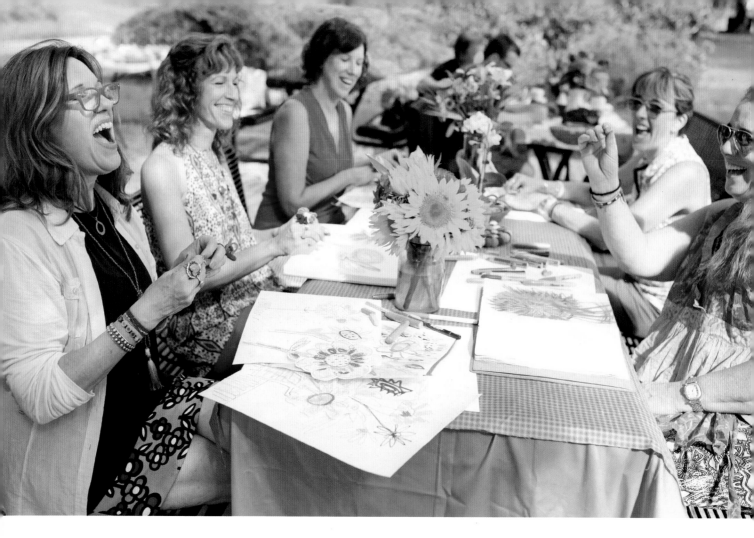

learning, sharing, and community

"Let us be grateful to people who make us happy; they are the charming gardeners who make our souls blossom." —Marcel Proust

Finding your community of artful, like-minded folks is like coming home to the place where you belong. There is nothing like laughing with your tribe and sharing your addiction to art supplies, your love of color, your excitement about materials, and your delight in nature. You get them, they get you, and you enjoy a "communication shorthand" because you are interested in and excited about so many of the same things. There are few things in the world better than being a part of a group and doing the things you love together.

We have a lot of artists in our family: my husband, John; both of our mothers; and John's brother Jim. John's family started McRae Art Studios, a big warehouse with twenty other artists' studios, more than twenty-five years ago. Our group is diverse, from painters to jewelers,

ceramists to sculptors. We host two fine art sales every year, as well as several open studio nights, workshops, movie nights, music gatherings, and more. I highly recommend this wonderful way of working. With close-knit kindred spirits, you can support each other's growth, celebrate new work, cheer on tiny victories, and understand struggles. Being a part of a community allows you to be inspired and to inspire. Encourage and be encouraged and have a ton of fun. Win-win.

Take workshops and have art making days with friends. Gather your art supplies, family, and friends and make things together. Take turns teaching each other. I cannot say enough about the power of community, either in your neighborhood or in the big, diverse global community. The joys, the growth, the many, many smiles are all a treasured part of an art-filled and wonderful life.

enjoying your path

"All life is an experiment. The more experiments you make the better."
—Ralph Waldo Emerson

Almost everything about art making can also be applied to life. The more you paint and draw, the more doors will open with each experience you try. Each path is different and yours will continue to unfold exactly as it should. You will gather some exciting information here and there, try out new techniques, play, travel, and be inspired by the color and sights and sounds and flavors of all types of wonderful things you meet along the way. A song or a new tool can send you off in a new direction, and if you are open and willing to follow the trail, exciting things will happen and new doors will open. If you trust yourself in your creative pursuits, anything is possible.

A HUGE part of following your path is saying yes. If something feels like the logical next step, then why not go for it? Yes takes you places. Yes brings you fun, interesting, new people. How wonderful it is to see your artful life revealing itself to you, day by day. Sometimes saying no is just as powerful as saying yes. I finally said no to my very fun job at Nickelodeon Studios, so I could say yes to more time making art. That no was the perfect yes! Yes to me! So I encourage you to say yes to YOU! Your dreams, your notions, your big, delicious desires, even a yes to more chocolate. Ask yourself along the way, "How much fun can I have?" Why not? It's your perfect path! Enjoy!

Just like a painting, things unfold at the perfect pace. Take a minute and look back at the crazy path and connections that led you to where you are today. Were there signs pointing to painting? Art making? Have you been doing it forever? I started painting, which led me to working at Nickelodeon Studios, which led me to paint sets, which taught me to be free with materials, which led me to pull discarded set walls out of the dumpster so I could paint on them, which lead me to do my first art show, where I met my first collector, which finally led me to say no to Nickelodeon and yes to my own art. Showing our artwork led my husband and me to travel across the country, which led me to my beloved art tribe pals, which led to teaching, which led to playing music, which led to writing songs, which all led to a deep knowing about simply saying yes. Yes, please!

my creative wish for you

"Creative people are curious, flexible, persistent, and independent with a tremendous spirit of adventure and a love of play." —Henri Matisse

Perhaps it's a day like no other, where the sunlight hits you so perfectly that you feel like a varnished painting by Vermeer, where your day spills out ahead of you like so many arching fields of harvest wheat.

I want your coffee to be strong and hot like Jamaica. I want your skin to tingle with the smoothness of a magnolia petal and the shine of a fresh apple breakfast.

I want you to dance, and I want you to sing. I want you to make things. String words together, knit stories, and draw intersecting lines. I want you to submerge your mind in rich, vibrant color.

I want you to make yourself laugh and take risks. I see you in full force and I feel like you are an important part of this larger quilt of humanity. Your creative acts matter, more than you realize. If you do it, then I can do it, so we all help ourselves by example.

We are in this creative stew together, and I want us to simmer and then boil over. Frolicking under the sky blue, a ruckus beach party, all sea-soaked and free. Untamed. Leaving nothing held back.

Okay, that's it. Go move your hands. Make something. Play. Share. Have fun.

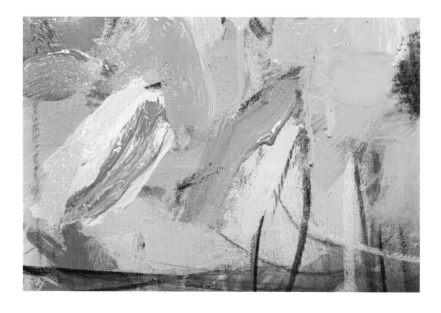

playing favorites

We will end with a quick game you can play in your sketchbook. Grab a pen, scribble a little bit, and pick your favorite of these twosomes.

- horizontal or vertical
- loud or very quiet
- sweet or salty
- soft or hard
- poetry or rap
- classical or dance music
- rough or smooth
- structured or free flowing
- serious or goofy
- outdoors or indoors
- city or country
- day or night
- fast or slow
- girl or boy
- orange or green

- sun or rain
- water or mountain
- sunflower or rose
- yes or no
- patterned or solid
- bright or dim
- neutral or vibrant
- thick or thin
- red or pink
- warm or cool
- ice cream or cake
- spatter or drip
- cat or dog
- merry-go-round or swing set

Finally, what would you love to experience, more than anything else, in your artful life?

Sending you hugs, enthusiasm, and encouragement.

May all of your creative wishes come true!

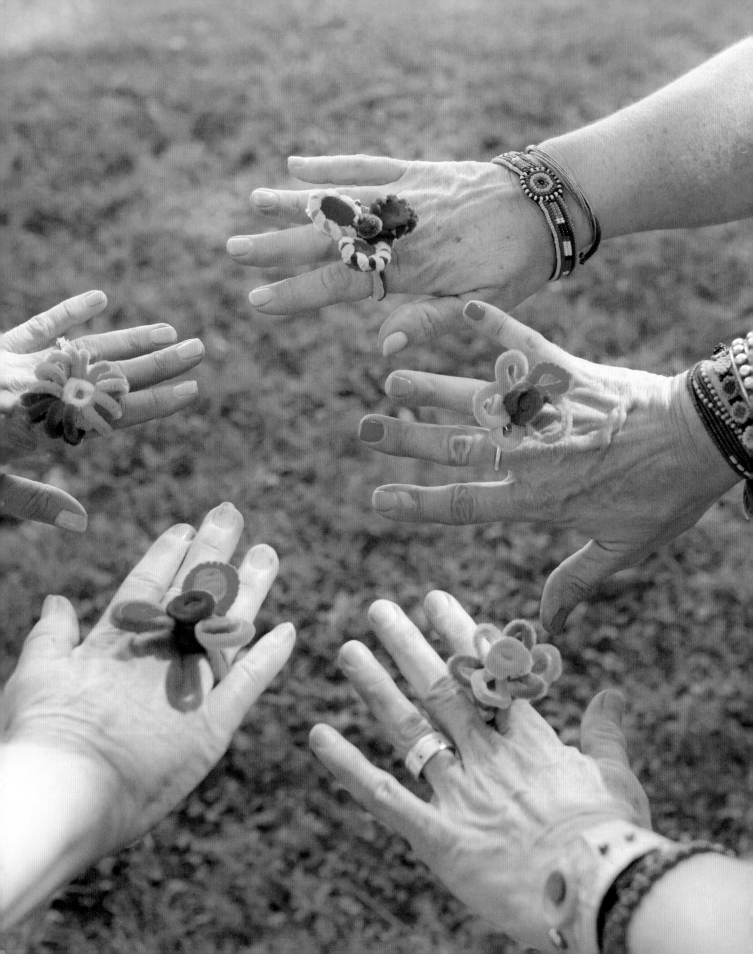

acknowledgements

Thank you! Thank you for taking a peek at this book and for your willingness to open up to your creative possibilities.

Big, giant love and gratitude to all of the amazing "Bloomers" who have so beautifully and bravely approached the canvas with wild abandon. Your support of each other, your unending joy, and your belief of your own artful possibilities inspire me beyond measure. I am honored and thrilled to be a part of this big-hearted, art-filled community.

Enormously huge hugs to my dear Mom. Your cheerful, artful ways have been an extraordinary inspiration for me and for all who know you. Thanks, Mom! I could not love you more.

To my dearest husband, John: I love you big time. You are the most creative, funny, kind, good-looking, and talented person I have ever known. I am forever grateful to have you to share this beautiful world and grand art adventure with. YES!

To the incomparable Jim Whipple for his fabulous cooking, songwriting, and creativity. You make our world more delicious in many ways.

And to my sweet, funny pals: Jane Harrison, Nina Chatham, Karen Sunshine Duncan, Heidi Behr, Kiaralinda, Cindy Biehl, Cathy Holt, Diane Culhane, and Debbie Barnes. You are the best, the brightest, and so much more. I love, love, love you! Life is better, fuller, and more joyful because of you.

A special shout-out to my McRae Art Studios family: You all inspire daily. Thank you for the art making and laughs we have enjoyed together over the years. Extra thanks to Don Sondag, whose giant talent, thoughtfulness, and dorky sense of humor made me a better and happier painter.

Thank you, Carla and Steve Sonheim, for your brilliance, talent, and friendship. Working alongside you, creating online classes, has been an exciting and imaginative adventure. I have unending respect and appreciation for you both.

To Mary Ann Hall, Meredith Quinn, Marissa Giambrone, Debbie Berne, and the great folks at Quarry Books: I deeply appreciate you all for your kindness, patience, and encouragement. I am truly grateful for your vision and creativity. Thank you, thank you!

To Terri Zollinger for your brilliant photography and zest for life: Thank you for capturing the colorful, playful spirit of painting and for making the entire process seamless and fun.

And last, but not least, a warm, fuzzy snuggle to our dear golden retriever, Kaya. Thank you for snoring at my feet, for your cute face, and for your constant wagging tail. Your special, sweet ways make every day more filled with love.

about the author

Lynn Whipple loves to paint, play music, and make things with her hands. She believes in finding the joy and fun in creativity. Lynn's in-person workshops and online classes have encouraged thousands of others to approach painting and art making with freedom and childlike enthusiasm. Her community of big-hearted creatives, the "Bloomers," beautifully embrace the ideas of working in layers, staying in the moment, and delighting in all the possibilities along the way.

Lynn's expressive Bold Bloom paintings can be found in galleries, museums, books, and in public and private collections across the globe. She lives in a colorful, lakeside home in Winter Park, Florida, with her artist husband, John, and their sweet golden retriever, Kaya.

about the photographer

Terri Zollinger, a lifestyle photographer for ten years, loves to document life and the art life creates. Photography was always an interest but became prevalent in Terri's life after she had children. One thing led to another and Terri Zollinger Photography was created. She has captured many milestones, life-changing moments, and marketing images for more than 500 clients across the United States. She looks forward to the new adventures and possibilities on her photography journey. Terri lives in Florida with her husband and two children. To see more of her work, visit www.terrizollinger.com.

Spanki Mills